IMAGES
of America

CHANDLER

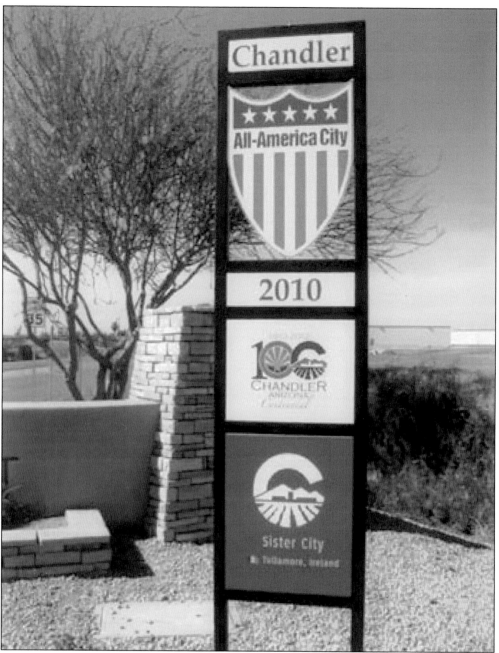

The City of Chandler has earned many accolades. Its most recent award is the prestigious All-America City award, which it won in 2010. This recognition came two years before the city celebrated its centennial in 2012. Chandler is also happy to be a sister city of Tullamore, Ireland.

ON THE COVER: Children wait to attend a movie at the Rowena Theater in 1943 in the midst of World War II. To gain entry to the movie, a child had to provide a piece of scrap metal for the war effort. Many children are holding the scrap metal they intend to donate, and three are wearing their metal pot donations as hats.

IMAGES
of America
CHANDLER

Jody A. Crago, Mari Dresner, and Nate Meyers

ARCADIA
PUBLISHING

Published by Arcadia Publishing
Charleston, South Carolina

Printed in the United States of America

Library of Congress Control Number: 2011942154

For all general information, please contact Arcadia Publishing:
Telephone 843-853-2070
Fax 843-853-0044
E-mail sales@arcadiapublishing.com
For customer service and orders:
Toll-Free 1-888-313-2665

Visit us on the Internet at www.arcadiapublishing.com

*To the families of Chandler who have made this community
a wonderful place to live for the last 100 years.*

CONTENTS

ACKNOWLEDGMENTS

This book belongs to the community. Without thousands of people's memories, photographs, experiences, and stories, this book would not have been possible.

There are a number of people and organizations that contributed to the research, development, and production of this work. We are indebted to the following people and organizations: Mayor Jay Tibshraeny; Vice Mayor Trinity Donovan; Councilmembers Jeff Weninger, Kevin Hartke, Matt Orlando, Jack Sellers, and Rick Heumann; the City of Chandler Centennial Steering Committee; the City of Chandler Museums Advisory Board; Oskar Munoz and Indira Berndtson and the Frank Lloyd Wright Foundation; Brian A. Spencer, AIA; Dorothy Woods Ruoff and the Chandler Historical Society; Suzanne Price Propstra, Diane Willian, and the Price Propstra family; Renee Levin, Dawn Jones, and the Intel Corporation; Catherine May and the Salt River Project Archives; Adam Lovell and the Detroit Historical Society; Steve Spiller and the Mission Inn Museum; Gary Heath and the Chandler Police Department; Dick McBlane, Mark Tope, and the Chandler Fire Department; Rob Johnson and Bashas' Supermarkets; John Bratcher and the Chandler Regional Hospital; the Library of Congress; the National Archives; Arizona State University Archives; the United States Bureau of Reclamation; Sara Lee and the Special Collections National Agriculture Library; Marlin Broek and Valley Christian High School; Earnest Robinson and the Chandler Unified School District; Josh Roffler and the Tempe History Museum; Terrell Suggs and his mother, LaVerne Kennedy-Suggs; Dave Lang, Shawn Hubbard, and the Baltimore Ravens; Aaron Harris and ICAN; Mindy Elias and the Boys and Girls Club; Desiree Fuschino; Adriana Milinic; Cheryl Milot; Rita Widmer; Phyllis Johnson; Andrea Squires; Sarah Crago; Josh Ransco; Jordan Golobich; Ali Mueller; Sarah Lampson; Olivia Hammond; Gordon Benson; Rich Dlugas; Mark Eynatten; Joe Martin; Tom and Bryan Lambke; Scott Solliday; Jean Reynolds; Elsie Johnson; Eddie Encinas; Joe Garcia; and all of the families who donated images to the Chandler Museum over the last 43 years. And, last but not least, thank-yous go to our families who have given their encouragement and support through the entire process of writing this book.

Unless otherwise noted, all photographs in this book are from the City of Chandler's Chandler Museum collection.

INTRODUCTION

Chandler, Arizona, lies on the high plain between the Salt and Gila Rivers. This area was one of the last in the East Valley to be settled because of the challenges of bringing water. Despite these conditions, Native Americans have called the area home for thousands of years. The Huhugam successfully irrigated the area for at least 1,000 years, growing a multitude of crops including squash, maize, and cotton. When Anglos began traveling through Arizona to California in the 1840s, they encountered the Pima, who were very productive farmers. They were raising wheat, beans, watermelon, and other subsistence crops, which they shared with the travellers. The land was also fertile for other peoples like the Mexican Yaqui, who settled in an area of today's west Chandler.

The passage of the Desert Land Act in 1877 opened up broad swaths of land for individuals or families who were willing to settle, irrigate, and farm their property. The legislation allowed people to claim 320 acres as an individual or 640 acres as a married couple at $1.25 per acre. Claimants had to have a witness to prove that they had irrigated the land within three years. While this system encouraged many honest people to make claims, it also encouraged fraudulent ownership and land speculation. A handful of people took advantage of loopholes in the Desert Land Act, and they were able to acquire thousands of acres.

Into this period of development and land speculation entered Dr. Alexander J. Chandler, a veterinary surgeon from Coaticook, Quebec, by way of Detroit. The story of the city of Chandler begins on August 8, 1887, when 28-year-old Chandler was approached regarding the position of territorial veterinary surgeon for Arizona. Despite taking a pay cut from his successful Detroit veterinary business, he saw an opportunity to make money on the open lands of the arid West. He accepted the job, but after 30 days, Chandler resigned his post to pursue greener options in California. After an arduous two-day stagecoach ride, the monsoon rains arrived in Phoenix at the same time that Chandler did, preventing him from proceeding to California for three weeks. What Chandler saw was that the rain had turned the desert into a veritable garden. He decided then that after visiting California he would return to Arizona, not to care for livestock but to green the desert. Doctor Chandler, following the examples of W.J. Murphy and Benjamin Fowler, utilized loopholes in the Desert Land Act to acquire a ranch of 18,000 acres south of Mesa.

In addition to farming his land, Chandler started a business consolidating the irrigation system on the south side of the Salt River. He worked to develop new canal systems, made contracts with Tempe and Mesa to deliver water to those communities, created a hydroelectric power plant, and dug wells to deliver water to his 18,000-acre ranch. He raised cattle, sheep, ostriches and other fowl, melons, citrus, peaches, dates, cotton, alfalfa, and other vegetables and fruits.

In the first decade of the 1900s, after the construction of Roosevelt Dam ensured a steady supply of water, Chandler's 18,000 acres became more valuable as real estate than as an agricultural operation. Chandler subdivided his land into individualized farm parcels and planned the layout of a new city in the East Valley that would bear his name. To advertise the sale of his land, Doctor

Chandler and the Chandler Improvement Company bragged in promotional materials that "the semi-tropical climate, the almost continuous sunshine, the deep rich sandy loam soil and an incomparable supply of water from the finest irrigation system in the world makes Chandler Ranch the most attractive location for the fruit raiser and gardener in the United States today." Many people gambled their savings to invest in the sure bet of Chandler farmland. In comparison to the expensive farmlands of Southern California, Washington State, and Oregon, the cheap land and bountiful yields in Chandler seemed to promise the American dream. In planning for the new city of Chandler, Doctor Chandler looked for inspiration from Southern California, in particular Pasadena. Built on a main railroad line, Pasadena sprang up as a resort community surrounded by industrial agriculture near a large thriving city, Los Angeles. Pasadena had a reputation as a luxurious destination, where wealthy Easterners spent their winters. Doctor Chandler envisioned a similar development in the Salt River Valley close to the booming city of Phoenix. He brought irrigation engineers, contractors, architects, investors, and boosters to Arizona from Southern California to plan a community and bring attention to the new town of Chandler. A national advertising campaign proclaimed Chandler to be the "Pasadena of the Salt River Valley" and promoted the fertile soil and year-round growing season for industrial agriculture interests.

To ensure that the Pasadena model would work in Chandler, Doctor Chandler planned the ultimate resort hotel for the Salt River Valley that would attract discerning vacationers from across the country. A year after Chandler opened the townsite for settlement in 1912, the San Marcos Hotel opened to great fanfare, with Vice Pres. Thomas Marshall and prominent Eastern and California businessmen in attendance. The hotel promised the most modern amenities, such as 1,500 incandescent lightbulbs, telephones in every room, and more than three miles of copper wiring. As it matured, the San Marcos, with its luxuries, became a favorite vacation spot of businessmen, celebrities, and politicians from across the country. Guests could rent a room or, ultimately, a bungalow for the winter season to take advantage of activities, such as trips to Roosevelt Dam, horseback rides to the mountains, polo, and golf on Arizona's first grass course. Through subsequent owners like John Quarty, the San Marcos remained a popular tourist destination.

Though Doctor Chandler left the agriculture industry, the plan for industrial agriculture in Chandler took off. Alfalfa became a profitable crop to feed the growing cattle ranches. Thousands of acres of alfalfa were planted throughout Chandler by many farmers and ultimately led to the construction of an alfalfa mill to process the crops. Chandler's land at the foot of the San Tan Mountains was unique in that it was protected from hard frosts, creating the ideal environment to grow citrus. Growers at the Chandler Heights Citrus Tract ultimately joined California growers to create the Sunkist brand. With abundant feed, the dairy industry became a pillar of the agricultural economy in Chandler. Truck crops, including melons, lettuce, potatoes, and sugar beets, became profitable to grow in Chandler. Doctor Chandler's best-known legacy is related to ostriches, which is ironic since he raised the birds for only a short period of time. His most lasting legacy is cotton. Doctor Chandler was the first in Arizona to grow long-staple cotton, which became one of the most profitable and widely grown crops throughout the state. During World War I, the Goodyear Rubber and Tire Company invested in Chandler. The company leased 8,000 acres of land from Doctor Chandler four miles south of town.

Chandler's planning also involved great architecture. Doctor Chandler met and hired Frank Lloyd Wright to design several projects in Chandler. While this collaboration failed to result in the construction of any permanent structures, the two men remained friends. When Wright was searching for a place in Arizona to establish his architecture school, Chandler gave him space in an old hotel known as La Hacienda. After spending a couple of winters at La Hacienda, Wright and his students moved their school to Taliesin West in Scottsdale.

World events impacted the agricultural oasis that was Chandler. After the attack on Pearl Harbor, Chandler residents rushed to help with the war effort. More than 500 of the town's 1,300 residents eventually served. Those left at home helped by growing victory gardens, holding scrap metal and bond drives, and filling the void left by those who enlisted. Some would-be soldiers and sailors left high school to enlist. To remember those serving, the community erected an honor roll

billboard listing the names of everyone from the Chandler area. The war effort expanded locally when the military established a pilot-training facility just east of Chandler. Williams Air Field grew to be one of the largest such training facilities in the country during the war. Thousands of people, including both civilians and military personnel, moved to Chandler because of the base. Because it was the closest town, those who lived on the base would travel to Chandler to bank, shop, watch movies, and socialize with community members. After the war, the base, renamed Williams Air Force Base, continued to grow. In the late 1940s, Williams began training jet pilots, which continued for the rest of its existence. In the 1970s, it graduated the Air Force's first class of female pilots. Williams Air Force Base closed in 1993, and the property is now home to Phoenix-Mesa Gateway Airport.

Chandler's history was enriched by the work of groups endeavoring to improve the community, serve residents, encourage civic engagement, and care for children. Some organizations were short-lived, while others have served the community for 100 years. National organizations made their mark in Chandler, while homegrown organizations came together to confront local issues. An entire book could be dedicated to the work of these countless organizations.

While younger than Phoenix, Tempe, and Mesa, Chandler has long been a leader in the Valley of the Sun. From innovative agricultural techniques to standout athletes, Chandler residents can claim many accomplishments. Doctor Chandler was the community's first visionary leader. He led the way in bringing water to the valley using new irrigation technology and techniques. Chandler was also the first person to plant long-staple cotton in the region, creating an entire industry for Arizona. He led the way in alternative energy, building a hydroelectric plant and experimenting with solar energy. The foundation that Doctor Chandler created encouraged others to pick up the mantle of leadership. Kenny England joined the local Future Farmers of America and worked his way up to become Star Farmer of America, the organization's highest honor. Chandler native Buddy Jobe bought a dusty racetrack in west Phoenix that ultimately grew into Zoomtown U.S.A. at Phoenix International Raceway, a jewel in the NASCAR empire. Chandler residents Carl and Berenice Dossey, Dale Smith, and John Clem demonstrated Chandler's elite status as home to rodeo champions, and solidified the Chandler Rodeo's place on the national PRCA circuit. Chandler has produced outstanding athletes in other sports, including Adam Archuleta, a defensive back who played with the St. Louis Rams in Super Bowl XXXVI (2002); Cody Ransom, the first player to hit a home run in his first two at-bats as a Yankee; and the only former city councilman to fight Muhammad Ali, Zora Folley. Chandler's business environment has nurtured both homegrown businesses and the high-tech industry. Bashas' Supermarkets began in a small store and grew into Arizona's favorite family grocery. Chandler's political leadership, in an effort to diversify the local economy, sought to build the Silicon Desert, bringing Rogers Corporation, Intel Corporation, Motorola, and other semiconductor and high-tech businesses. Chandler has also led the way in societal change. Years before the Supreme Court ended segregation, Chandler High School integrated. As Chandler looks to the future, businesses like aerospace giant Orbital Sciences, biotech leader Covance Laboratories, and many others will ensure that Chandler remains a leader throughout the 21st century.

From its beginnings in the late 1800s to its bold steps into the 2000s, Chandler has been a place where individuals come together in the spirit of community to create a wonderful place to live. Thousands of individual stories are woven together to create the modern patchwork quilt that is Chandler today.

One

DOCTOR CHANDLER AND THE GREENING OF THE DESERT

The often-told story about Chandler's beginnings features the arrival and almost immediate departure of town founder Dr. Alexander John Chandler. The tale begins on August 8, 1887, when 28-year-old Chandler, an up-and-coming Canadian veterinarian who had made a national reputation for himself at his private practice in Detroit, arrived in the territorial capital of Prescott. He came to Arizona to accept the position of territorial veterinary surgeon. What he found was a land that was experiencing one of the most severe droughts in its history. For the year and a half before his arrival, the territory had only 6.7 inches of cumulative rain. Chandler found that cattle were dying at an alarming rate, and all the vegetation was burned up. After 30 days on the job, he resigned his post to pursue greener options in California. A board member convinced Chandler to visit his ranch in southeast Arizona prior to making his final decision. After an arduous two-day stagecoach ride, the monsoon rains arrived in Phoenix at the same time Chandler did, preventing him from proceeding to California for three weeks. What Chandler saw was that rain had turned the desert into a veritable garden. He decided then that after visiting California he would return to Arizona, not to care for livestock but to green the desert. As with all founding stories, there is as much myth as truth in this account of A.J. Chandler's arrival. The real narrative concerns an intelligent businessman who had a plan for the future.

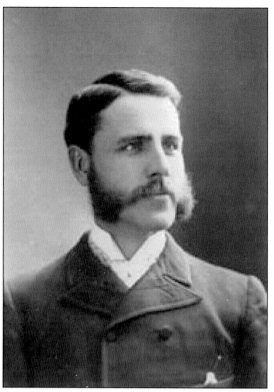

Veterinarian and town founder Dr. Alexander J. Chandler lived in Detroit before moving to the Arizona Territory. Born in 1859 in the small town of Coaticook, Quebec, Chandler attended McGill University in Montreal. Graduating in 1882, he worked as a livestock inspector for the Canadian government before going into private veterinary practice in Detroit. In 1887, officials from the Arizona Territory went to the US Department of Agriculture for a recommendation for the newly created office of territorial veterinary surgeon. Doctor Salmon, the chief of animal husbandry, looked no further than A.J. Chandler, who was making a name for himself in Michigan. The territorial officials were quite surprised when he took the job, since it meant a heavy cut in pay. At left is a portrait of Doctor Chandler c. 1887. Below is the Chandler family homestead in Coaticook.

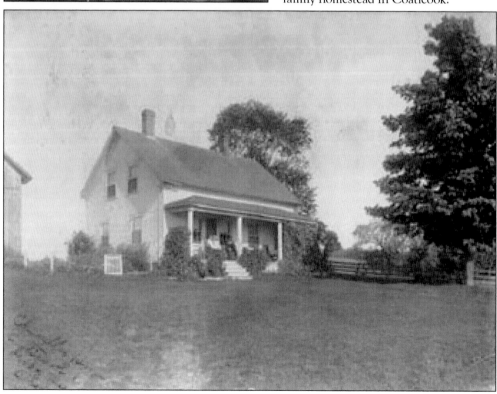

Doctor Chandler met Dexter Mason Ferry and Charles C. Bowen in the 1880s. Ferry had been a prominent citizen of Detroit for 30 years, known for his nationwide seed company. Pictured right, Ferry was also involved in banking, insurance, railroads, and real estate. C.C. Bowen was secretary-treasurer of the Ferry Seed Company, which had revolutionized commercial farming and at-home gardening through the first mail-order seed business. Ferry and Bowen provided the capital for Doctor Chandler to purchase thousands of acres of land in Arizona. Ferry, Bowen, and their sons continued to be major investors in Doctor Chandler's business ventures. In the picture of the Ferry Seed Company leadership below, Ferry is seated on the left and Bowen is standing behind him. (Below, courtesy of Detroit Historical Society.)

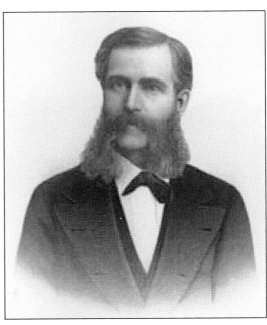

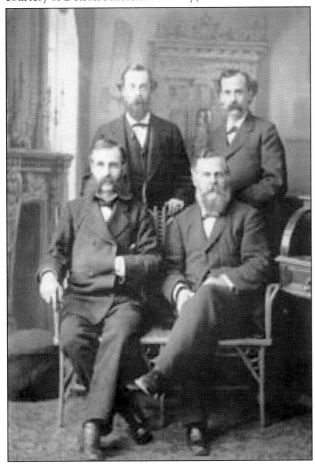

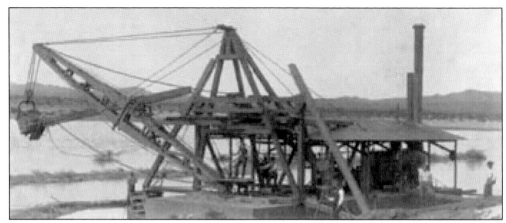

Doctor Chandler believed he could water his newly acquired land by improving the Mesa Canal. In 1891, after two years of negotiations, Doctor Chandler finally received approval from the Mesa Canal Company to expand the waterway to a minimum of 40,000 miners inches of water and become the new manager of this canal. To expedite the work of improving the canal, Chandler contracted with the Marion Steam Shovel Company to purchase a medium-sized ditching dredger for $10,000, and it was put into use that same year. Dredgers are used for excavating dirt to create new waterways.

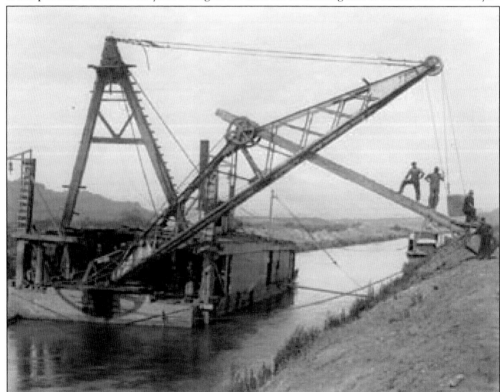

The Marion Steam Dredger was so successful that Doctor Chandler ordered a larger dredger for $25,000. While at work excavating, the dredgers created a spectacle, drawing local and national attention. Visitors came to see these desert curiosities at work day and night. Chandler paid $50 per day for a four-man crew and fuel to operate the machines around the clock. Thousands of cords of wood were brought from the abandoned Fort McDowell to keep them in operation.

The expansion of the Mesa Canal provided so much additional water that Doctor Chandler was able to create two new canals: one to water his ranch lands to the south and one to provide hydroelectric power and water to Tempe. These new canals required additional equipment for construction and maintenance. Chandler purchased a third dredge, a land-based and steam-powered machine, to aid with this work.

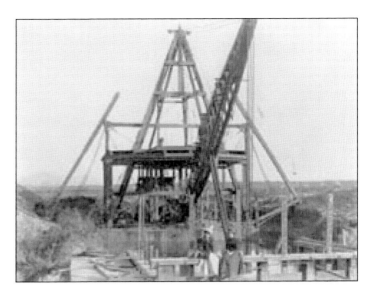

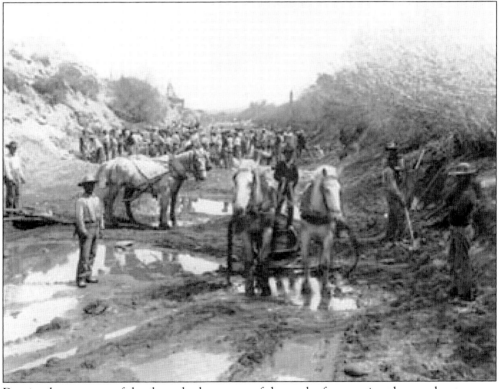

Despite the presence of the three dredges, most of the work of excavating the canal system was done by Fresno Scrapers. This shovel-like blade was pulled by teams of horses and removed the sandy soil. The Consolidated Canal construction utilized more than 100 teams of horses day and night to accomplish this engineering feat in one year. This photograph of canal construction on the north side of the Salt River exemplifies the physical labor of both man and beast. (Courtesy of Salt River Project.)

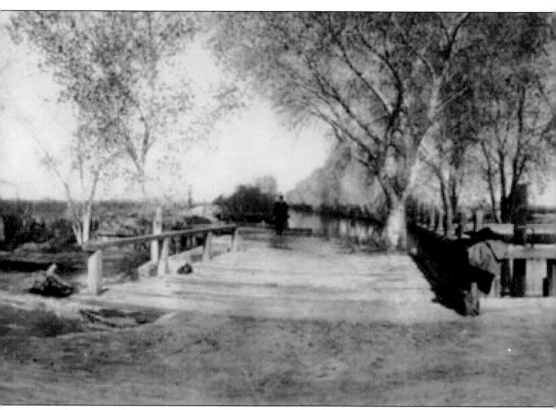

After a year of construction in 1892, the Consolidated Canal began delivering water on the south side of the Salt River. In Mesa, the canal branched three ways to send water to different parts of the East Valley. This photograph shows the Consolidated Canal division gates. Flowing from the left is the Mesa Consolidated Canal, bringing water from the Salt River to the division gates. In all, 33,000 miners inches of water flowed east and south in the canal towards Chandler Ranch,

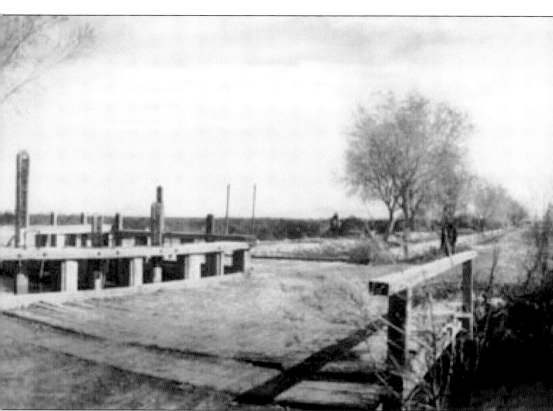

an area that had never received that much water. The smallest canal branching away from this division is the Mesa Canal. Chandler had promised Mesa farmers 7,000 miners inches of water. On the right side is today's Tempe Crosscut Canal. The Tempe Crosscut also provided hydroelectric power to people living on the south side of the Salt River. (Courtesy of Panoramic Photographs, Prints and Photographs Division, Library of Congress, LC-USZ62-136821.)

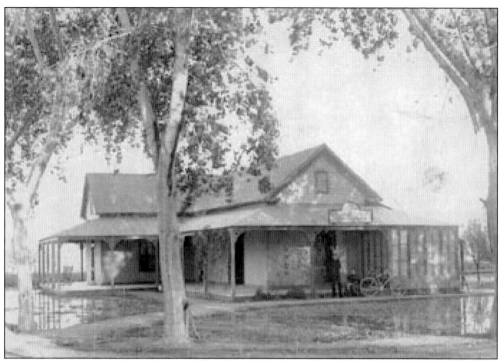

In 1892, Chandler, Ferry, and Bowen incorporated the Consolidated Canal Company, with offices in Phoenix and Mesa. The company had $1 million in capital and was tasked with constructing, maintaining, and operating the irrigation system on the south side of the Salt River, including canals, pipelines, gates, and dams. The photograph above shows Doctor Chandler's house and office on his ranch in Mesa. Below are the home and office of Consolidated Canal Company irrigation engineer William H. Code.

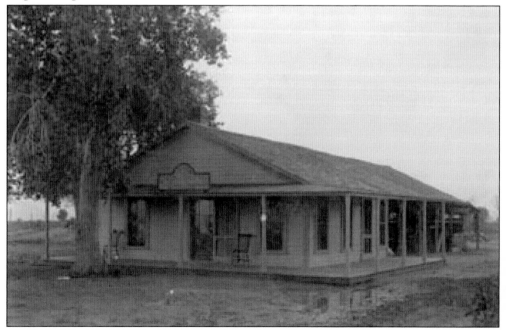

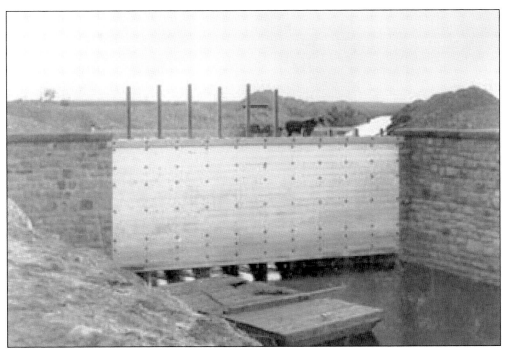

The headgate of the Mesa Consolidated Canal was located off the Salt River a few miles north and east of the town of Mesa. The structure controlled the flow of water from the river into the canal system that fed the Tempe Crosscut, Mesa, and Consolidated Canals. According to a *Mesa Free Press* article in 1894, preservative paint designed to last up to 20 years covered all wooden surfaces. The headgate was 44 feet wide and 24 feet high, with 10 gates to control the flow of water. The new headgate was a vast improvement over the old one, which was made of brush and had been repeatedly washed out during floods.

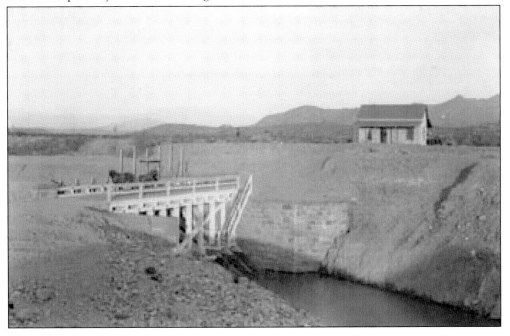

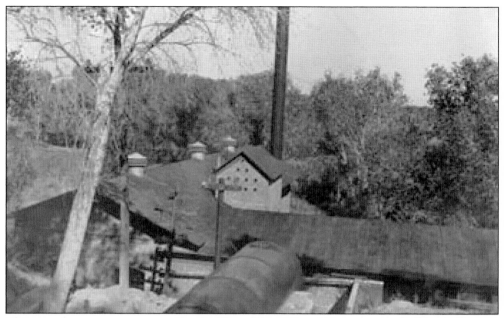

This powerhouse was constructed by the Consolidated Canal Company on the Tempe Crosscut Canal. Doctor Chandler purchased this land and planned the power plant to take advantage of canal water flowing over the edge of a naturally occurring mesa to create hydroelectric power. The electricity was then sold to customers in Mesa, Tempe, and, later, the town of Chandler. The Mesa Canal Company felt that Chandler was unfairly profiting from its water, and the two sides went to court to argue their cases. Ultimately, the Supreme Court ruled in favor of Chandler.

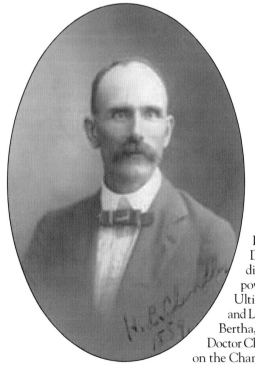

In 1891, Harry L. Chandler joined his brother Doctor Chandler in business. After a number of different ventures, Harry managed the hydroelectric power plant for the Consolidated Canal Company. Ultimately, Harry incorporated the Southside Power and Light Company as a separate entity. He and his wife, Bertha, had two children, Louise and Marian. Because Doctor Chandler had no descendants, Harry's family carried on the Chandler legacy in the Salt River Valley.

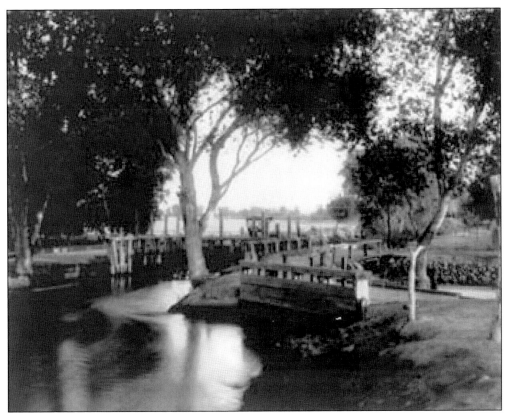

While the division gates, pictured above, remained an important part of the Consolidated Canal system throughout its history, they were the subject of many lawsuits. Both Mesa and Tempe farmers sued Doctor Chandler's Consolidated Canal Company, claiming that Chandler illegally benefited from the new canal system. Another lawsuit involved the creation of a waterfall in the Mesa Canal, pictured below. Ultimately, Doctor Chandler testified before Congress and the Supreme Court regarding several of these lawsuits. (Above, courtesy of the National Archives and Records Administration.)

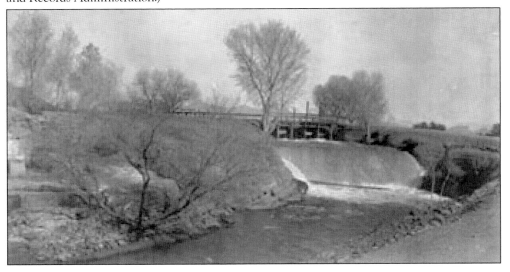

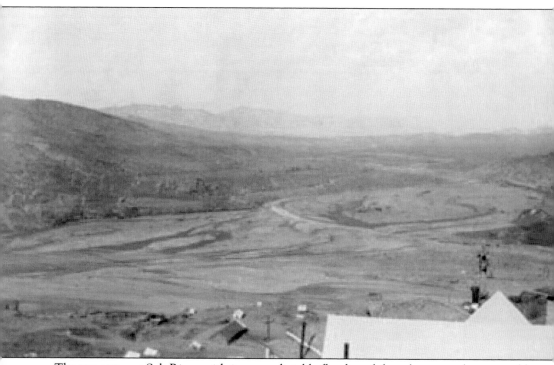

The tempestuous Salt River, with its unpredictable floods and droughts, caused many problems in the Valley. Farmers and irrigators longed for a reservoir that would tame the river. There were many stalled attempts at building a dam and reservoir, some as early as 1889. The Hudson Reservoir Company made a very serious attempt in 1893. This effort failed when the company was unable to raise the $3 million needed to complete the project. A group of local irrigators, farmers, and land speculators formed the Salt River Water Users Association to make another try. Until this time, reclamation was a privately funded endeavor. The Salt River Water Users Association was successful in convincing the US Bureau of Reclamation of the immediate need for a dam and reservoir on the Salt River. The Roosevelt Dam project became the first federal project funded under the 1902 Reclamation Act.

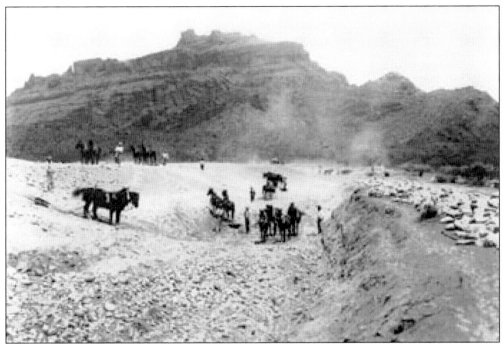

Heavy floods in 1905 destroyed the diversion dam for all the canals on the north side of the Salt River. This prompted the US Bureau of Reclamation to purchase the northern canal system and build a new diversion dam that would serve all the canals both north and south of the river. Construction on the diversion dam, known as Granite Reef, began in 1906 and was completed in 1908. After its completion, this dam became a popular tourist destination. In the photograph below, people are not only seen observing the top of the dam but also playing in the water below the dam. (Above, courtesy of Salt River Project.)

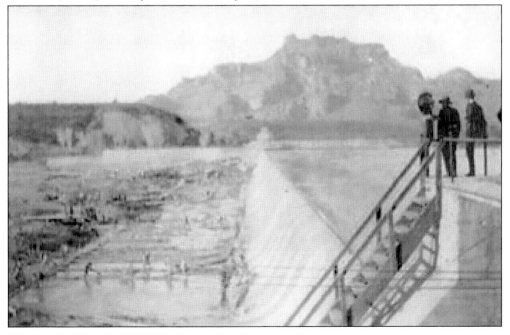

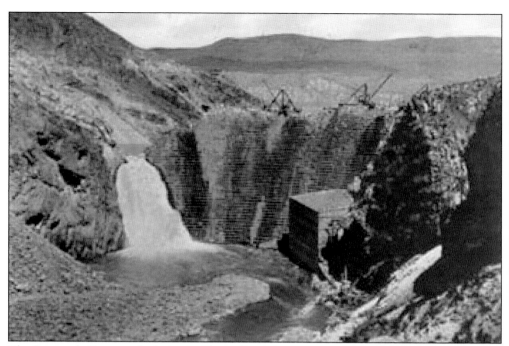

The Roosevelt Dam was built in the Tonto Creek box canyon, at the confluence of the creek and the Salt River. The first project funded by the US Bureau of Reclamation, construction on the dam began in 1906. This was one of the last stone masonry gravity dams built in the United States. At conclusion of construction, former president Theodore Roosevelt came to dedicate the dam on March 18, 1911.

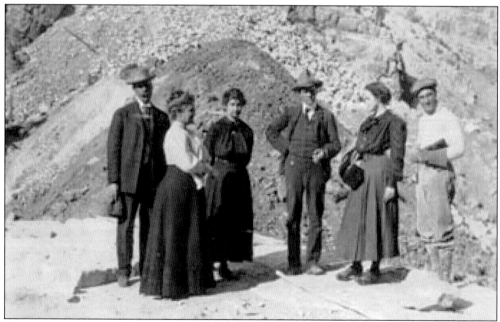

The Roosevelt Dam construction site was a popular tourist destination. In this picture, Doctor Chandler joins a group of intrepid travelers who drove more than 60 miles from Mesa to the dam site along the Apache Trail. Doctor Chandler stands on the left in this 1908 image.

Always the innovator, Doctor Chandler was looking for machinery that would make irrigation work easier. Like his earlier steam dredgers, this 1913 steam-powered ditcher helped carry out the immense work necessary to create and maintain the vast numbers of irrigation ditches and laterals. With its revolving buckets, this machine could dig 1,500 to 2,500 linear feet of irrigation ditch per day.

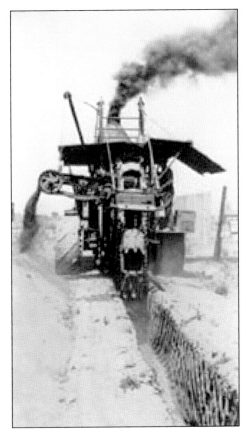

Doctor Chandler's work resulted in a vast network of canals, laterals, and irrigation ditches. Here, the Lewis family works to flood irrigate their crops using water delivered from one of the many irrigation ditches.

Driveway 1915

With the delivery of water, the desert literally turned green with agricultural fields. The photograph above shows fruit orchards on the Lewis Ranch. In the background, the fast-growing town of Chandler stretches from horizon to horizon. The new San Marcos Hotel is visible in the center. In the picture below, taken a few years later, the Lewis homestead is surrounded by seemingly never-ending cotton fields.

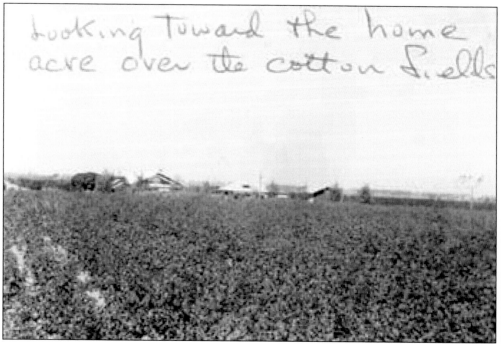

Looking Toward the home acre over the cotton fields

Two

THE SAN MARCOS HOTEL

A year after official settlement of the town of Chandler began in 1912, a new luxury hotel opened. Doctor Chandler named the San Marcos Hotel for Fray Marcos de Niza, the first European to enter the Salt River Valley nearly 400 years earlier. The hotel opened with great fanfare, with Vice Pres. Thomas Marshall in attendance as well as prominent Eastern and California businessmen. The resort promised the most modern amenities, such as 1,500 incandescent lightbulbs, telephones in every room, and more than three miles of copper wire. When it opened in November 1913, the San Marcos Hotel was the only electrified building in town. On March 28, 1913, the *Chandler Arizonan* suggested that the room phones could be used by guests to "sit in your room with a view of the green valley before your eyes while you are talking to snow-covered Chicago or shivering New York." As it matured, the San Marcos became a favorite vacation spot for businessmen, celebrities, and politicians from around the nation. Guests could rent a room or a bungalow for the winter to take advantage of activities such as trips to Roosevelt Dam, horseback rides to the mountains, polo, and golf on Arizona's first grass course. Through subsequent owners like John Quarty, the San Marcos remained a popular tourist destination. Over its history, despite being shuttered for several years, the San Marcos Hotel has been and continues to be an important anchor for Chandler's downtown business district.

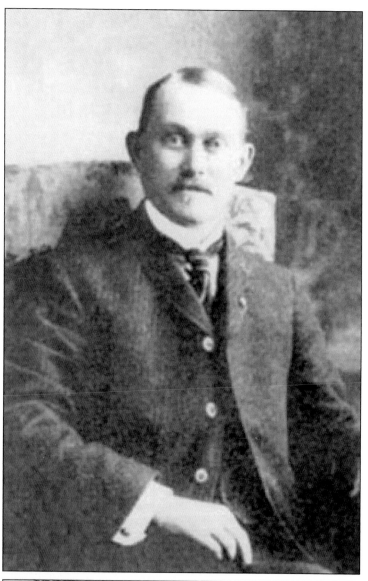

Doctor Chandler's vision for the newly founded town of Chandler included a grand resort hotel where wealthy visitors could spend the winter months. To make this hotel a reality, he hired Arthur Burnett Benton, a well-known Los Angeles architect who specialized in Mission Revival style. Benton was known for designing the Los Angeles YWCA, otherwise known as the Mary Andrews Clark Memorial Home, and the Mission Inn in Riverside, California. Below is Benton's architectural rendering of the San Marcos Hotel. (Left, courtesy of the Mission Inn Museum.)

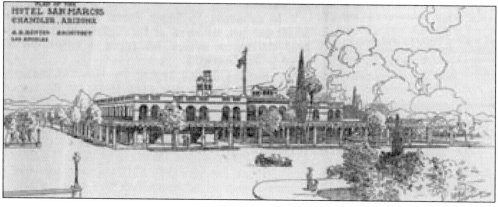

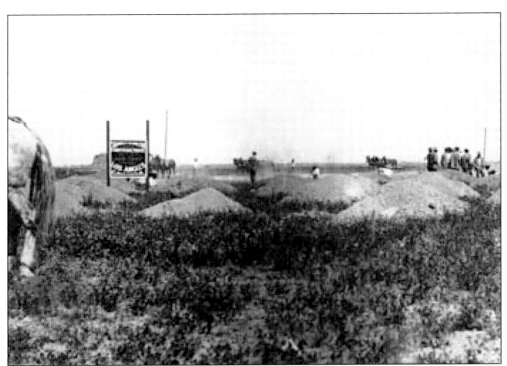

Excavation work on the San Marcos began prior to land sale day on May 17, 1912. The project was started to show potential land purchasers that the hotel would be a reality. The Los Angeles firm Sears & Gilbraith was the contractor hired to excavate the site. Not long after, Chandler hired C.B. Weaver, another prominent Los Angeles contractor, to construct the building. In the photograph right, Doctor Chandler enjoys an ice cream cone on land sale day at the future site of the San Marcos Hotel while watching the work. Piles of dirt from the excavation are visible behind him.

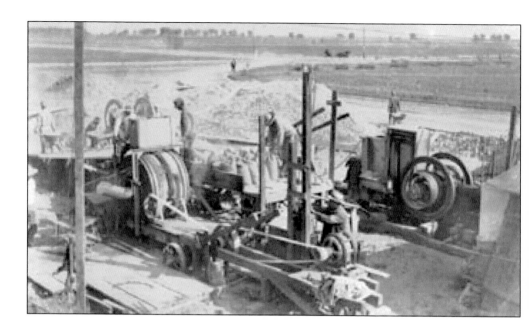

The plans for the San Marcos Hotel called for a fireproof building made out of reinforced concrete. This required massive amounts of concrete, stone, and steel, which were delivered from across the West. The stone and concrete were brought in by the Southern Pacific Railroad. Colorado Fuel and Iron Works in Pueblo, Colorado, was unable to keep up with the demand for steel, which led to major delays in construction. Some materials came from local companies such as the Chandler Lumber Company and the Chandler Brick Yard. The photograph above shows the rock and concrete crushing machinery at work creating concrete. Below, workers construct the distinctive ribbed ceiling of the hotel's second floor.

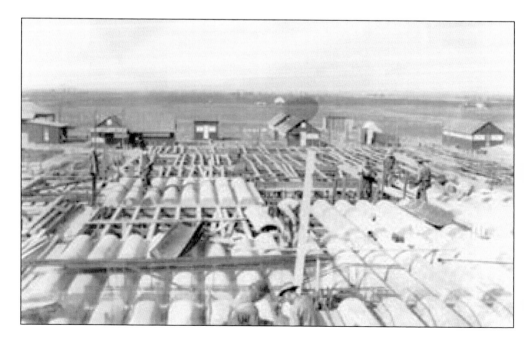

Between 100 to 150 men were employed in constructing the hotel. W.R. Hoag was the superintendent of construction, but he resigned in October 1912 and was replaced by Harry Jennings. Frank Newman was the head of the plumbing crew; J.M. Stein was the machinist and engineer; S.S. Bradley was the electrician; and Joe Cashman was the general manager. Some of the workers came from California, but Hoag expressed a preference for hiring local men to work for him.

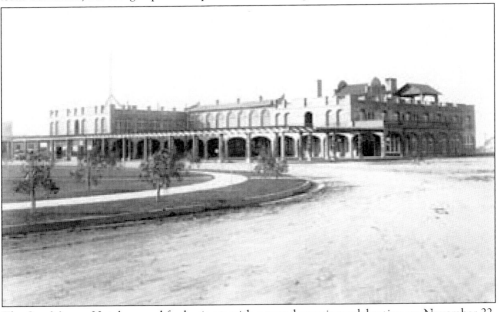

The San Marcos Hotel opened for business with a grand opening celebration on November 22, 1913. Five hundred people attended the opening gala, including Vice Pres. Thomas Marshall, Arizona governor George Hunt, and Rep. Carl Hayden.

Grace Robinson (left) was hired as the first general manager of the San Marcos Hotel. She had previously worked at the Ingleside Inn, the Salt River Valley's first resort, and received training in hotel management at the Mission Inn in Riverside, California. The Mission Inn was another of architect Arthur Burnett Benton's projects. While at the Mission Inn, Robinson observed Korean immigrants working at the hotel. Consequently, she hired many Korean workers at the San Marcos.

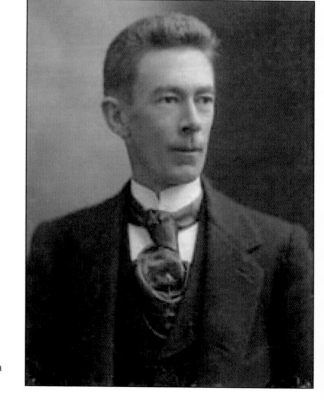

Will Robinson, Grace's husband, assisted Grace in managing the San Marcos. He also built the less-expensive Suhwaro Hotel across the street from the San Marcos. Will was a prolific Arizona author of books and essays.

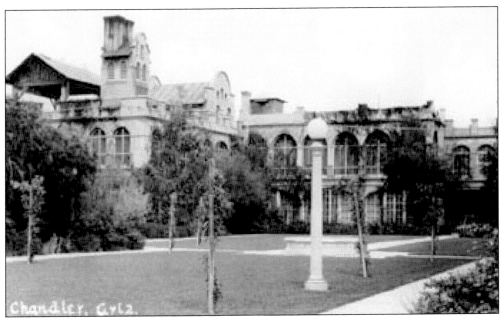

Behind the hotel, an electrically lighted concourse stretched to the west. Guests would enjoy the fine Arizona sunsets during after-dinner walks. An orange grove was planted in the grassy center of the concourse. This photograph was taken shortly after the young orange trees had been planted.

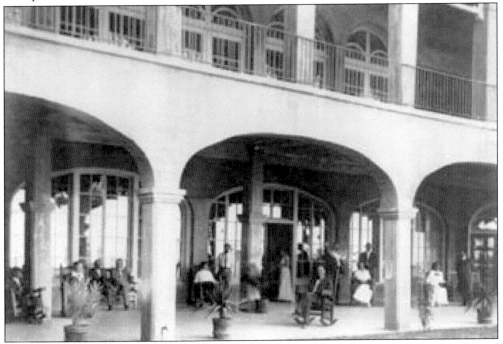

One of the most popular features of the new hotel was the grand court, a covered patio and veranda on the front of the building. Here, hotel guests could relax in rocking chairs and share the latest news and gossip. Eastern visitors used the grand court extensively to enjoy Chandler's spectacular winter weather.

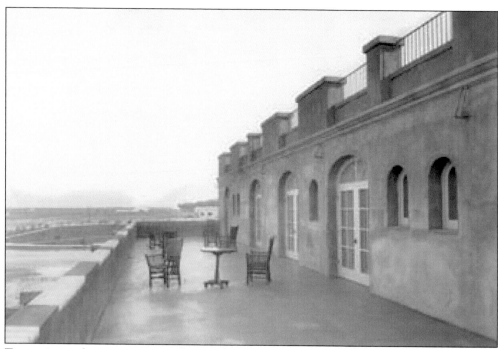

To maximize the temperate weather, each room in the hotel opened onto an outdoor patio or balcony. In this image, guests staying in rooms on the north side of the building enjoyed unobstructed views of the desert to the east and north of the hotel.

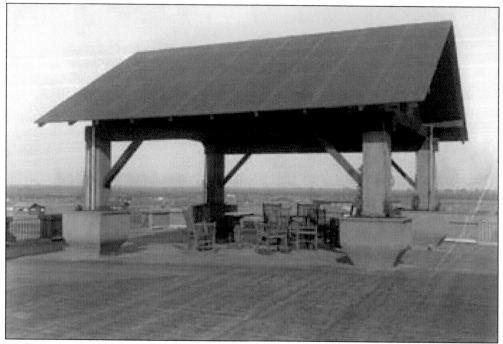

Architect Arthur Burnett Benton designed a Japanese-inspired teahouse atop the hotel. The teahouse offered guests a unique rooftop experience and beautiful views of the surrounding desert and distant mountains.

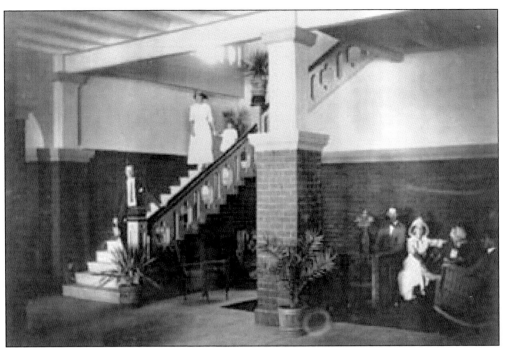

When entering the hotel, guests were greeted by a palatial lobby. The large fireplace and the support columns were decorated with bricks made locally at the Chandler Brick Yard. In this picture, guests enjoy a sitting area off the lobby near the grand staircase.

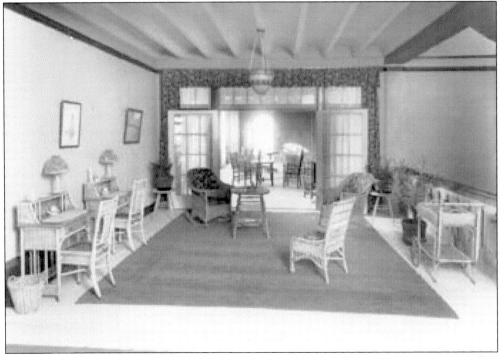

Comfortable wicker furniture was placed throughout the hotel. This is most likely the ladies' writing room at the top of the stairs above the lobby.

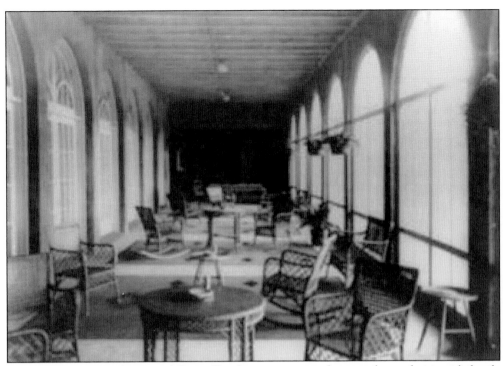

A reception room on the second floor offered guests a sunny place to relax and visit with family and friends.

The San Marcos guest rooms had many modern amenities. Each room featured a private bath, electricity, and a private telephone line. A two-light chandelier hung over the dresser, and writing desks featured recessed lighting.

Custom-made chandeliers lit the luxurious dining room that welcomed guests for lavish meals.

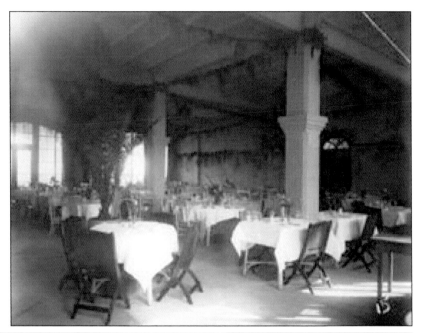

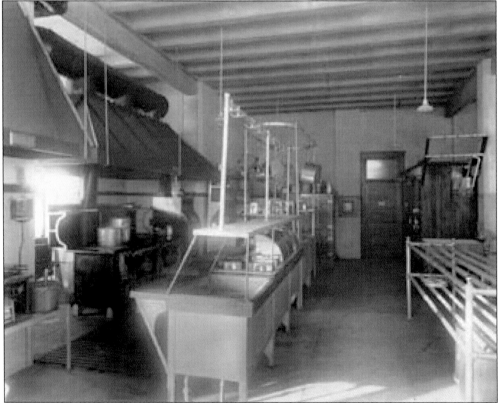

The hotel kitchen was located in the south building on Commonwealth Avenue and San Marcos Place. The kitchen provided lavish meals for hotel guests using the most up-to-date culinary equipment. Designers continued the distinctive ribbed ceiling in this building as well.

John Quarty was hired as general manager of the hotel in 1943, and with his debonair style, he quickly became the face of the San Marcos. Despite hard times resulting from the Great Depression, Quarty led the hotel to regain its former glitz and glamour. He soon became the owner of the hotel and operated it for more than 30 years, until his death in 1979.

John Quarty fostered an environment at the hotel that drew Hollywood celebrities, powerful businessmen, and prominent politicians. In this photograph, Quarty (left) walks the grounds of the San Marcos with Errol Flynn and Flynn's new bride, Nora Eddington.

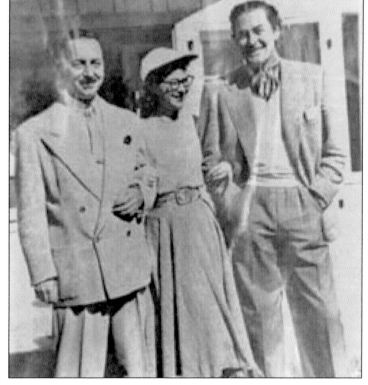

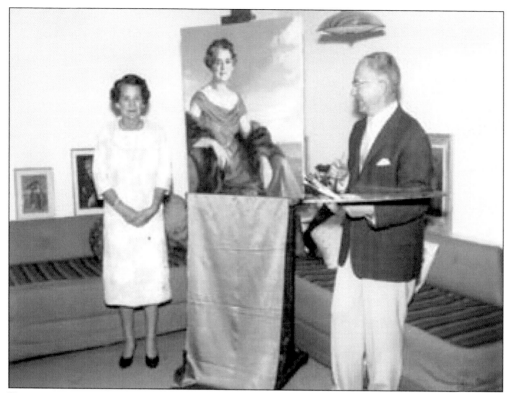

Famous portrait artist Fritz Werner spent many winters at the San Marcos. He delighted guests with his creative costumes at the hotel's themed parties and painted portraits for many of the guests as well as the local elite.

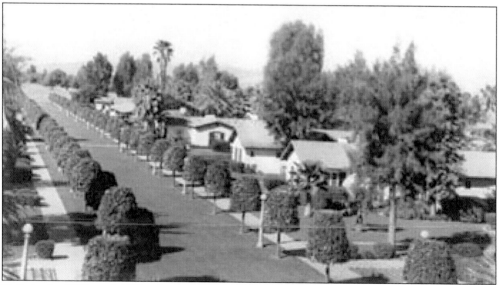

Built in the 1910s and 1920s, the San Marcos bungalows offered guests the privacy of their own house during their stay at the hotel. The bungalows were located on the concourse behind the hotel. Lush landscaping, fountains and pools, and an orange grove made visitors feel like they were in paradise.

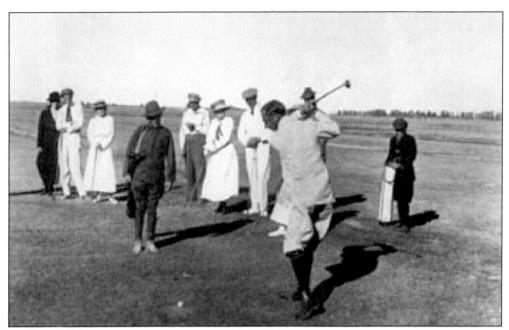

The San Marcos Hotel boasted the first grass golf course in Arizona. It was designed by Will Robinson. In this photograph, guest George Lewis tees off as a group of other guests looks on. The original golf course was across the square from the hotel. Later, in the 1920s, the golf course was moved to its present location west of the bungalows behind the hotel.

San Marcos guests had many choices when it came to recreation. In addition to the golf course, there was a swimming pool as well as polo grounds. The Desert Inn, shown here, was a destination for guests on horseback or in cars. Located in what is now Ahwatukee, the Desert Inn was in open desert to the west of Chandler. It offered the opportunity for wealthy guests to rough it in the desert by experiencing cowboy cooking, camping, and singing.

Three

Chandler, "The New Pasadena"

Doctor Chandler split his time between Arizona and Southern California, particularly Pasadena, in the late 1880s and the 1890s. In fact, Chandler is listed as living at a Los Angeles address in the 1900 census records. At this time, the Los Angeles area was growing, and Doctor Chandler was especially inspired by the Pasadena development model. Built on a main railroad, Pasadena developed as a resort community surrounded by industrial agriculture near a large city, Los Angeles. It was known as a luxurious destination where wealthy Easterners spent their winters. Doctor Chandler envisioned a similar development in the Salt River Valley near Phoenix. He brought irrigation engineers, contractors, architects, investors, and boosters to Arizona from Southern California to plan a community and bring attention to the new town of Chandler. A national advertising campaign compared Chandler to Pasadena and promoted the fertile soil and a year-round growing season for agriculture interests. Boosters also touted the San Marcos Hotel as a posh retreat for the discerning vacationer. While not immediately as successful as the California town, the Pasadena of the Salt River Valley laid the foundations for the community of today.

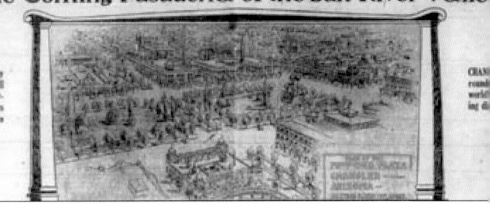

Throughout 1912, Doctor Chandler's national advertising campaign was trumpeting Chandler as the new Pasadena. On October 11, 1912, the local *Chandler Arizonan* newspaper quoted Doctor Chandler: "Chandler is now looked at as the second Southern California. We are going right ahead with our plans to make Chandler another Pasadena, the city beautiful of Arizona. A natatorium will be built as planned, spraying systems are being placed throughout the parks of Chandler right now. That is a system installed in no other park in Arizona. It is as beautiful as it is useful. Plans have been completed already for a modern domestic water system second to none in efficiency and quality in the entire southwest . . . in time Chandler will have a thousand homes and every house will be beautiful."

With the successful completion of Roosevelt Dam, Doctor Chandler began to parcel out his property. Buyers could purchase 10- to 40-acre farms or smaller residential and commercial lots in town. This photograph shows Doctor Chandler welcoming buyers to the Townsite Office at the corner of Commonwealth Avenue and San Marcos Place.

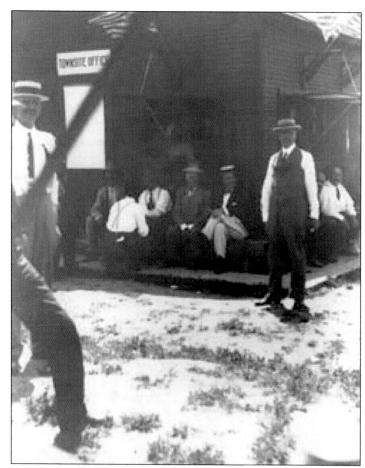

Prior to land sale day, Doctor Chandler advertised the opening of the Chandler townsite in newspapers across the nation. A caravan of buyers from California made the trip together and purchased several properties. These are a few of the cars that made the trek.

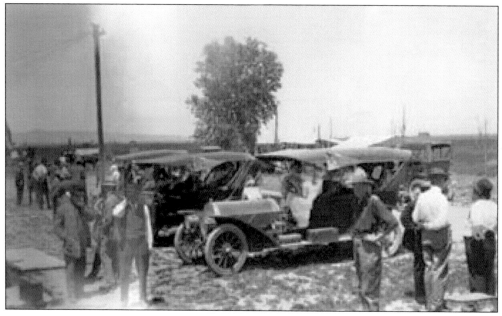

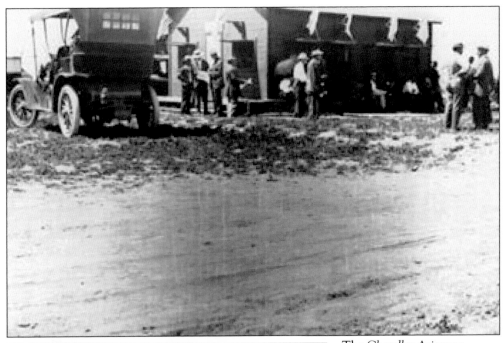

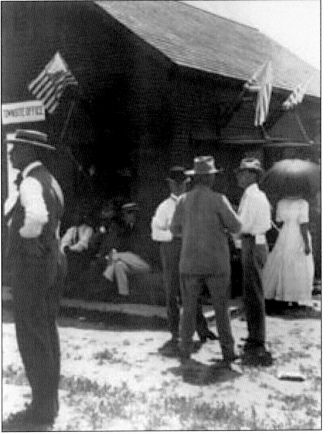

The *Chandler Arizonan* described land sale day as follows: "Without any flourish of trumpets, with an utter absence of anything bordering on the cheap methods used by hawkers of boomsites, Chandler, destined to be the Pasadena of the Salt River Valley, a city of a thousand beautiful homes, of palatial hotels, the finest pleasure resorts in the southwest, the cleanest home life, a city of churches and of the finest schools in Arizona, had its initial sale of lots on May 17th." Doctor Chandler, pictured left, provided buyers with a delicious lunch of sandwiches, eggs, fresh fruit, ice cream, coffee and lemonade. According to the newspaper, Doctor Chandler and his associates made no direct effort to sell land, letting the appeal of the land speak for itself. At the end of the day, more than $50,000 worth of lots were sold.

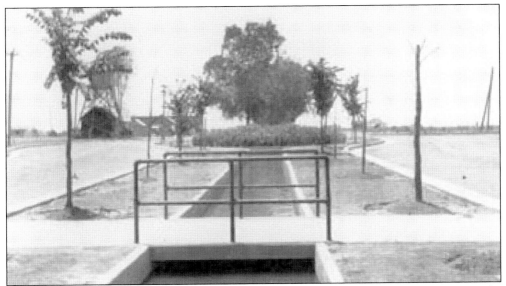

Even before land sale day on May 17, 1912, the Mesa Improvement Company (later known as the Chandler Improvement Company) outlined the new community's streets by installing concrete curbs. Paving would come later. This photograph depicts the Improvement Company's commitment to having a beautiful city with curved streets surrounding "the Beauty Spot," a lushly landscaped island in the middle of the Commonwealth Canal.

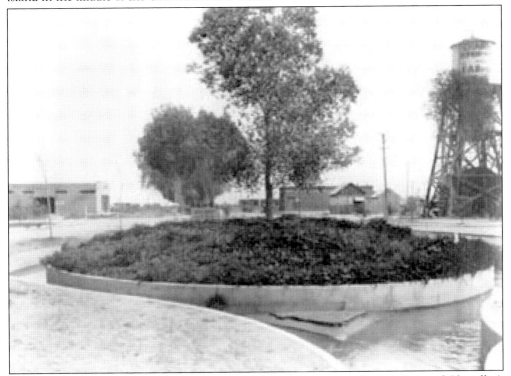

Here, the Beauty Spot is shown in a photograph with an eastward view. Some of Chandler's earliest buildings are in the background along the cottonwood-lined Commonwealth Canal. The water tower at right bears the Chandler Improvement Company name.

While the local newspapers promoted Chandler's beautiful homes and clean living, the early townsite was quite modest in reality. In this picture from 1912, the Land Sale Office and the grocery store are visible. The white-roofed buildings are tent houses, which served as temporary homes for people

living and working around Chandler. This photograph was taken from approximately the intersection of Chicago and California Streets, looking northeast. Visible at the far right, railcars transported goods along the tracks that are still located near Delaware Street in downtown Chandler.

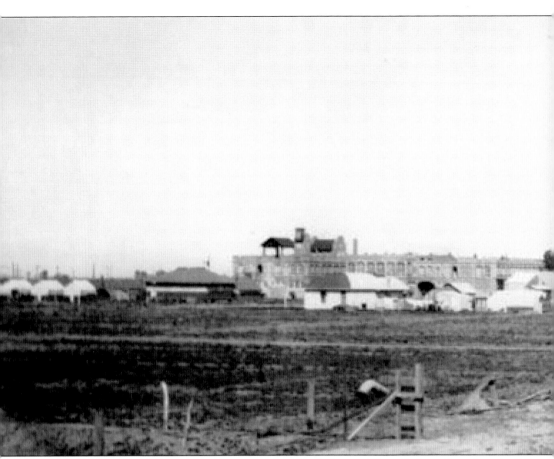

While the sales of downtown properties were brisk during Chandler's earliest days, building remained slow. In this picture from 1913, the San Marcos and a few businesses are surrounded by farm fields. This photograph was taken west of the intersection of Chicago and California Streets. The *Chandler Arizonan* reported on September 12, 1912, that Chandler's development

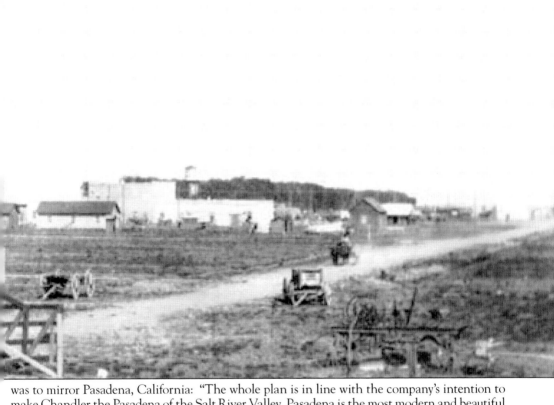

was to mirror Pasadena, California: "The whole plan is in line with the company's intention to make Chandler the Pasadena of the Salt River Valley. Pasadena is the most modern and beautiful of the American home cities."

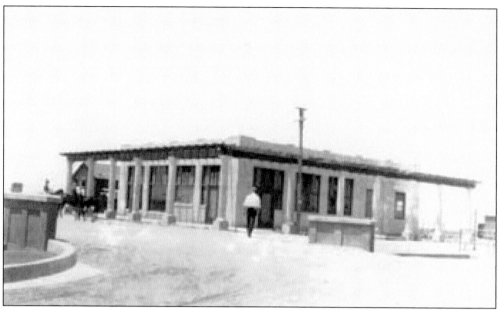

One of the first permanent buildings constructed in Chandler was located on the corner of Commonwealth Avenue and San Marcos Place. Its first occupant was the Bank of Chandler, which opened in February 1913. Originally capitalized at $100,000, the bank received $8,000 of deposits the first day it was open for business.

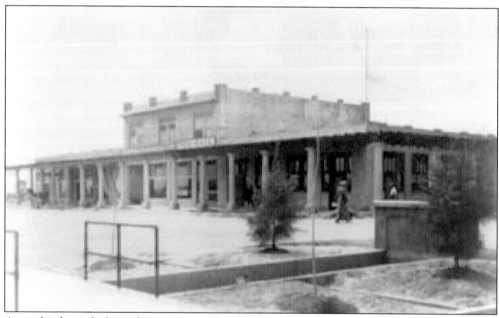

A couple of months later, the same corner had grown substantially. A new two-story structure first housed the chamber of commerce. Because fire had ravaged other communities during this time, it was an important selling point that each of these buildings was fireproof. The Chandler Improvement Company boasted that the downtown business corridor would be completely fire resistant.

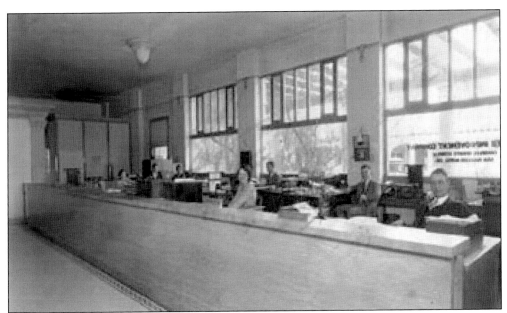

After the bank closed in the 1930s, the Chandler Improvement Company moved its headquarters into the Bank of Chandler building. Then, the Chandler Improvement Company entered receivership in 1936 after Doctor Chandler had mortgaged it in an attempt to finance other projects during the Great Depression. Doctor Chandler retired to a bungalow on the grounds of the San Marcos and could only watch as the company was liquidated in the early 1940s.

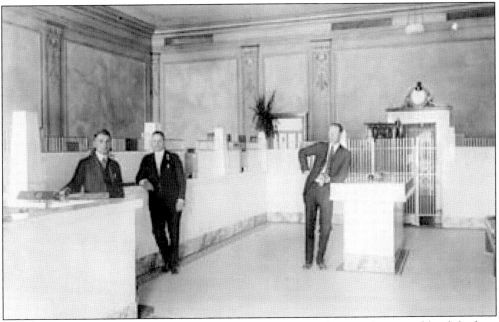

The First National Bank opened in 1920 on Boston Street. This was the second bank built in town. Its interior featured marble counters and tiled floors, and the exterior boasted faux marble columns. While the First National Bank was capitalized at $50,000, the local economy could not support two separate banks. The Bank of Chandler took over the First National Bank in 1925. Ultimately, this bank closed during the Great Depression.

Doctor Chandler's plan based on Pasadena featured a monumental park in the center of town. Tree-lined streets and canals were prominent traits of Pasadena, so one of the first improvements to the townsite included planting hundreds of cottonwood trees along the Commonwealth Canal. In this photograph, those trees had matured. This image also shows the fledgling trees in what ultimately becomes Dr. A.J. Chandler Park.

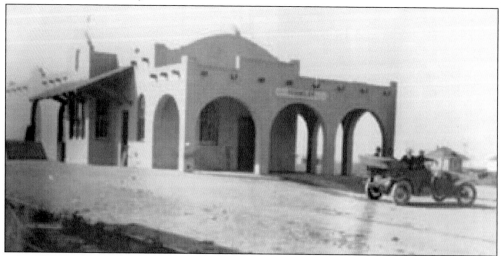

When the Southern Pacific Railroad was coming to the East Valley, it planned for a small station in Chandler. Doctor Chandler saw the plans and refused to grant right-of-way into Chandler until the railroad built a station he thought worthy of the town. Chandler's rail depot was eventually designed by prominent Phoenix architects Royal Lescher and John Kibbey. Built in the Mission Revival style, it welcomed many wealthy winter visitors coming to Chandler to stay at the San Marcos Hotel.

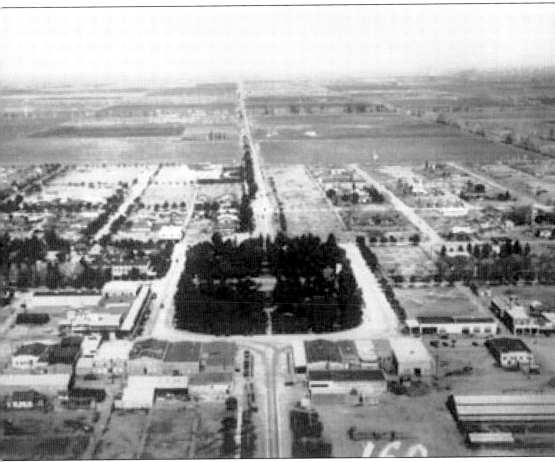

Taken in 1923, this photograph looks north towards Mesa. It shows Doctor Chandler's plan to echo the development of Pasadena coming to fruition. At the center of this image is Chandler's first park, a lush area full of tall trees. Canals and streets were also lined with trees, creating cool canopies over sidewalks and attractive vistas. The bustling business district had begun to surround the park. The San Marcos is visible on the left, identifiable from the other buildings by its landscaped grounds. Bashas' first Chandler store, a dry goods business, is the black-roofed structure in the lower right corner. State Route 83 (now Arizona Avenue/State Route 87) encircles the outside of the park.

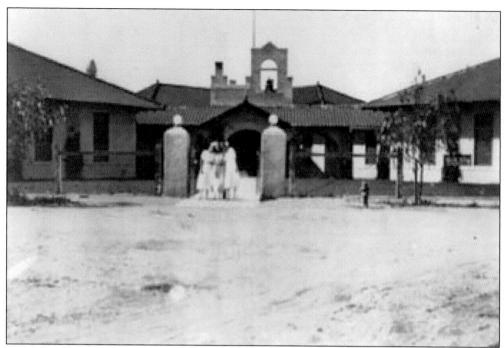

The Chandler Grammar School, Chandler's first formal educational facility and later known as Cleveland School, opened in 1912. It was located on Cleveland Street, which was later renamed Chandler Boulevard, just west of Arizona Avenue. The school was built in the Mission Revival style of architecture that was so prominently used in both Pasadena and Chandler.

The prices of houses in Chandler were dictated by zoning ordinances, which caused poor, mostly Hispanic laborers to move to the southern neighborhoods. In 1929, members of this neighborhood petitioned the school board to open a school for their children within walking distance of their homes. In response, Winn School, shown here, was built on Saragosa Street.

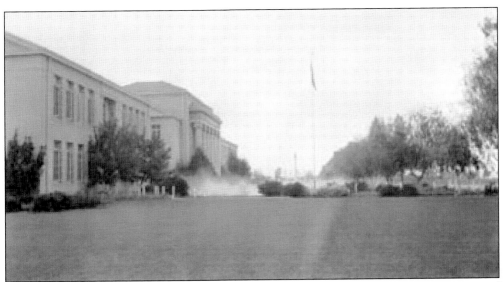

The monumental, Classic Revival–style Chandler High School was built in 1922 at a cost of $250,000. It was designed by the Southern California architectural firm Allison & Allison and was listed in the National Register of Historic Places in 2007. The building was the pride of the town. Its semi-fireproof construction boasted 1.75 million bricks, 3,750 barrels of cement, and only 70 linear feet of wood.

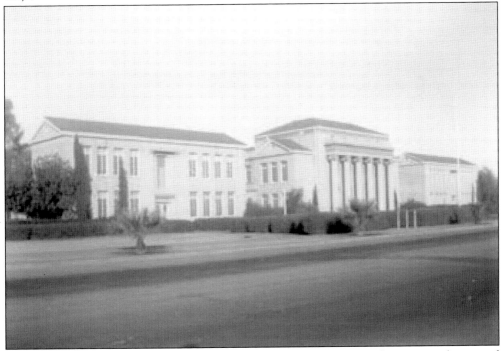

After the school was completed, it was used to attract settlers from across the country who wanted the best modern education for their children. Fred P. Austin, superintendent of schools in Chandler, described the school in promotional materials: "Standing like a wide-flung monument of tan gold against the Chandler sky line, the new High school building . . . marks a glowing period in the educational annals of the Chandler school district."

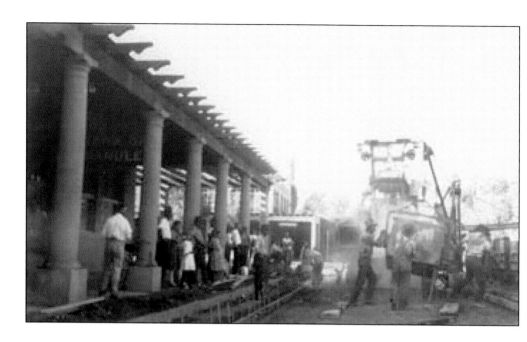

Downtown streets were paved in 1921, nine years after the town was opened for settlement. Maricopa County completed the paving, since Chandler was not yet an incorporated town. Town leaders waited until after the work was completed to incorporate, ensuring that the county would pay for the paving. The photograph above looks north on San Marcos Place. Visible on the left is the Bank of Chandler, and the San Marcos Hotel is in the background beyond the bank. In the photograph below, workers pave the intersection of Arizona Avenue and Boston Street. In the background of this image is the town's central park, later known as Dr. A.J. Chandler Park, with its magnificent landscaping.

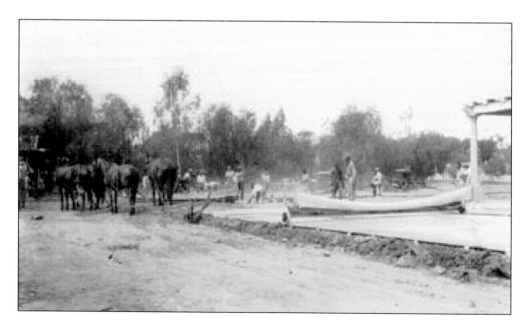

Doctor Chandler and the *Chandler Arizonan* boasted that Chandler was "a city of a thousand beautiful homes." In reality, home building went slowly. Many residences were mail-order kit homes. The houses built in the northeast section of town were mandated to cost at least $3,000 to build, a restriction that led the neighborhood to be known as the "silk-stocking" neighborhood.

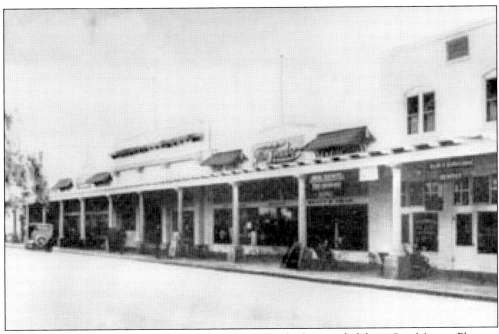

The business district continued to grow, and by 1920 had expanded from San Marcos Place to Boston Street. The two-story building on the far right housed the offices of Doctor Gilbert, Chandler's first physician, and Doctor Barackman, the first dentist. Next to the doctors' offices, from right to left, the buildings were occupied by a dry goods store called the Leader, the First National Bank, Reliable Hardware, and the Arrow Pharmacy on the corner.

Doctor Chandler's associate George T. Peabody was the founder and first secretary of the Chandler Chamber of Commerce. Like many of Chandler's investors, he had come to Chandler from Southern California. Peabody worked tirelessly to market Chandler, promoting the town in newspapers and at meetings around the country.

John D. Van Eaton, another Southern Californian, was the first editor of the local newspaper, the *Chandler Arizonan*. The paper began publication four days after land sale day, and it helped promote the fledgling town. The *Arizonan* was delivered by train to cities across the nation as an advertisement for the town. Van Eaton is pictured here in front of his tent house, which, he let readers know, was always open.

Four

INDUSTRIAL
AGRICULTURE

Even though Chandler featured Arizona's grandest resort hotel, the town's economy was firmly rooted in industrial agriculture. Doctor Chandler was Chandler's first farmer and rancher. On his 18,000 acres, he raised cattle, sheep, ostriches and other fowl, melons, citrus, peaches, dates, cotton, alfalfa, and other vegetables and fruits. In promotional material, Doctor Chandler and the Chandler Improvement Company bragged that "the semi-tropical climate, the almost continuous sunshine, the deep rich sandy loam soil and an incomparable supply of water from the finest irrigation system in the world makes Chandler Ranch the most attractive location for the fruit raiser and gardener in the United States today." Many people gambled their savings on the "sure bet" in Chandler farmland. In comparison to the expensive acreage in Southern California, Washington, and Oregon, the cheap land and bountiful production in Chandler seemed to promise the American dream. While some farmers such as the Dobson and Knox families had already settled here, countless families moved across the country to the new state of Arizona to pursue their livelihood in their own agricultural operation. The completion of the Roosevelt Dam seemed to ensure a steady and reliable supply of water that turned desert land into a veritable agricultural paradise.

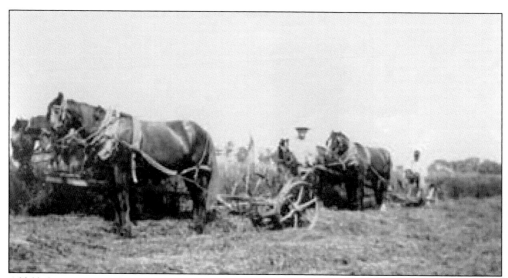

Alfalfa became a profitable crop in the Salt River Valley when the cattle industry transitioned from grazing to feeding cattle with alfalfa. On Chandler Ranch, Doctor Chandler grew 3,000 acres of alfalfa, which was enough to support 2,000 head of beef cattle and several thousand sheep. In addition, enough alfalfa was planted to supply seed to the Ferry Seed Company for nationwide sales. The climate in the Salt River Valley allowed farmers to get as many as a dozen harvests from one planting. By 1911, water was available to grow crops that could support large cattle feedlots. Above, laborers cut alfalfa. Below, cut alfalfa has been laid in the field to dry and is being collected and stacked.

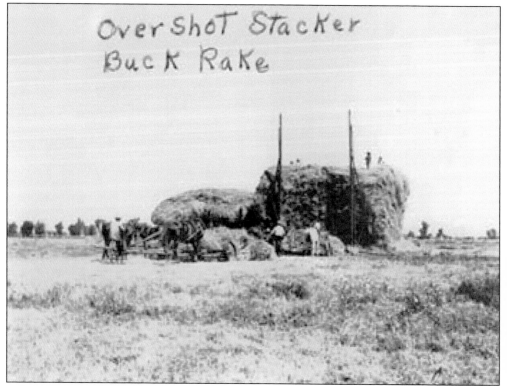

Owned by Hal Bogle and Roy Lockhead, the Pecos Valley Alfalfa Mill was established in Chandler in 1928 on what would later be known as Pecos Road. While some alfalfa mills dehydrated alfalfa and processed it into pellets or other feed, the Pecos Valley Alfalfa Mill processed sun-cured alfalfa into hay. The hay from this mill was fed to dairy cows and cattle in the Chandler area.

Feedlots were an important part of agricultural business. Here, Jackson Bogle looks over the Bogle feedlot on Frye Road. The Bogles bought the last of Doctor Chandler's land in 1946, shortly before they sold the Pecos Valley Alfalfa Mill and moved exclusively into cattle ranching. In purchasing 1,500 acres in Chandler, the Bogles added to their substantial landholdings across the West. Jackson and Barbara Bogle became important community builders.

In 1928, Doctor Chandler and the Chandler Improvement Company created the Chandler Heights Citrus District along Hunt Highway east of Chandler. The company planted 800 acres of orange, lemon, and grapefruit trees. The proximity of the San Tan Mountains and the elevation of the district at 1,450 feet protected the trees from frost. The citrus-packing plant at Chandler Heights (pictured) processed thousands of pounds of citrus.

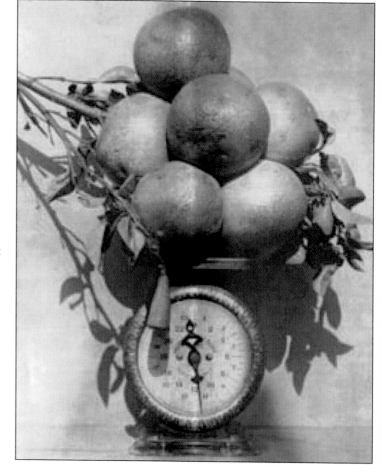

This photograph appeared in a promotional booklet produced by the Chandler Improvement Company touting Chandler's agricultural potential. It bragged that Chandler citrus was heavy, juicy, thin-skinned, and richly colored. The caption that accompanied the photograph read: "The scale tells the story—eight Chandler grapefruit weighing better than a pound apiece."

The citrus district offered an opportunity for growers to purchase a small lot with trees already planted on it. The district worked as a cooperative in which growers elected a board of directors that made decisions for the entire district. The Chandler District growers ultimately joined Sunkist Growers, Inc., a nonprofit cooperative of more than 6,000 Arizona and California citrus growers. In the picture to the right, an unidentified child poses beside a grapefruit tree. In the photograph below, Vera Cooper Smelser and her brother Ned Cooper pose for a picture in front of rows of citrus trees on their property in Chandler Heights.

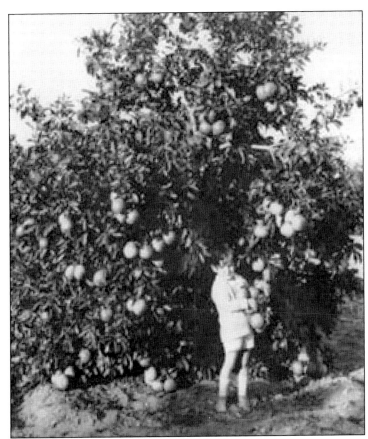

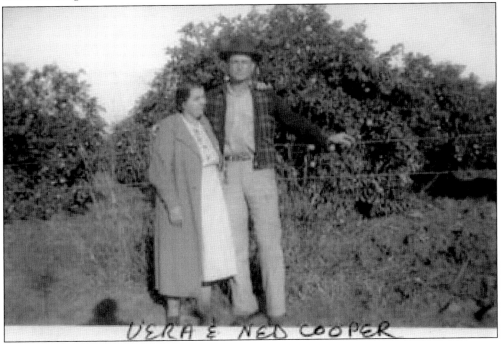

VERA & NED COOPER

During the Great Depression, the Farm Security Administration set up a cooperative farm north of Chandler's downtown to give work to farmers. In this photograph, a farmer feeds dairy cows, and chicken coops are visible in the background. Russell Lee photographed the dairy farm in May 1940. (Courtesy of Farm Security Administration/Office of War Information Black-and-White Negatives, Prints and Photographs Division, Library of Congress, LC-USF34-036117-D.)

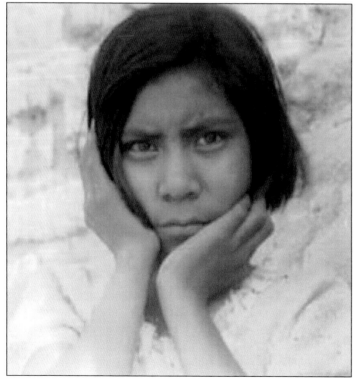

Photographer Dorothea Lange documented the work of the Farm Security Administration. Her iconic photographs symbolize the impact of the Great Depression on Americans. This image of the daughter of a migrant Mexican laborer was taken near Chandler in May 1937 and is one of her best-known photographs. (Courtesy of Farm Security Administration/Office of War Information Black-and-White Negatives, Prints and Photographs Division, Library of Congress, LC-USF34-016792-C.)

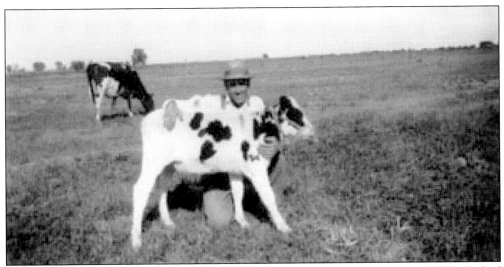

Dairying became a successful industry because mild winters and an abundance of alfalfa for feed allowed farmers to have large, well-fed herds, which produced high yields of milk. The demand for dairy products in Arizona was high, making dairies profitable and leading to massive expansion of the industry in the 1910s. In 1910, there were roughly 12,000 dairy cows in all of Maricopa County, and six years later there were 48,000 on lands watered by the Salt River Project alone. Newspaper advertisements pushing for the growth of the dairy industry in Chandler claimed that 10 cows could bring a profit of $100 every month. Above, Guy Whitten poses with one of his dairy calves. Below, in an image from a Chandler Improvement Company promotional booklet, dairy cows are seen feeding on alfalfa hay.

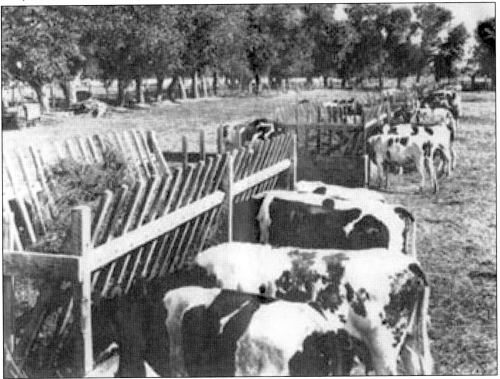

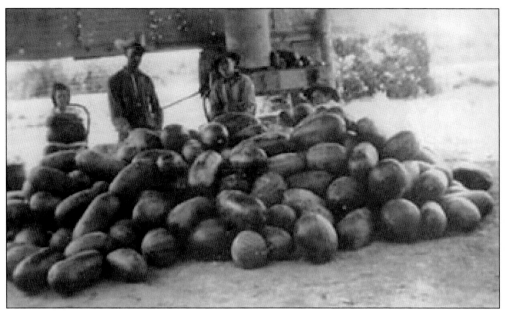

Melons of all sorts were grown in Chandler as a cash crop. National companies offered Chandler farmers lucrative deals for planting and harvesting melons. Above, unidentified farmworkers pose with a pile of watermelons on the Sossaman farm. On the photograph is written "our bread + butter 1918." Below, in an image taken from a Chandler Improvement Company promotional booklet, laborers pick and pack a bountiful crop of cantaloupes.

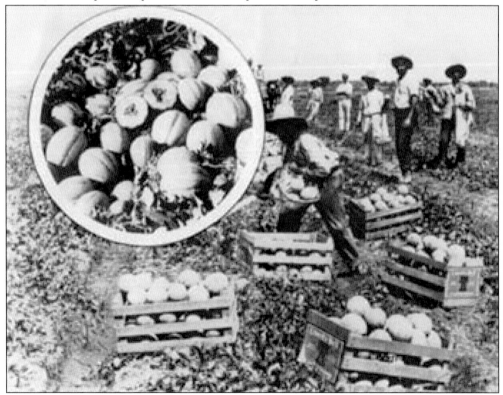

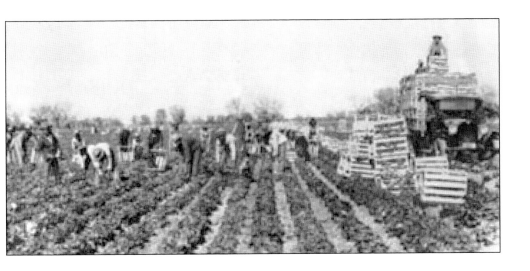

Like with other crops, Chandler's long growing season contributed to the success of the lettuce industry in the Salt River Valley. In 1931, it was a $10-million-dollar industry in the East Valley and brought business to lumber mills, trucking companies, ice factories, railroads, garages, and other support industries. These photographs come from a promotional booklet for the Chandler Improvement Company. The one above shows workers picking and packing leafy heads of lettuce into crates. Below, trucks full of lettuce-packed crates haul the leafy vegetable from fields to packing sheds.

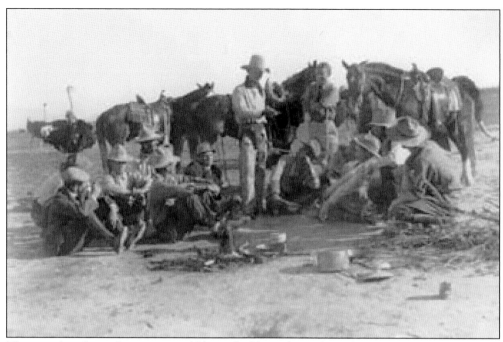

The ostrich industry became incredibly profitable in the early 20th century as ostrich feathers fetched hefty sums, especially in the fashion market. Doctor Chandler observed the large birds being raised on the only ostrich farm in the country, the Cawston Ostrich Farm in Pasadena, California, not far from his home in Los Angeles. In 1914, Doctor Chandler purchased a herd of ostriches from a farm west of Phoenix and hired cowboys to drive them across the desert to Chandler. After the ostriches stampeded on the drive, it took two days to round up the birds and complete the trip to Chandler. In the image above, ostriches surround camp during mealtime. Below, cowboys guide ostriches along the road to Chandler.

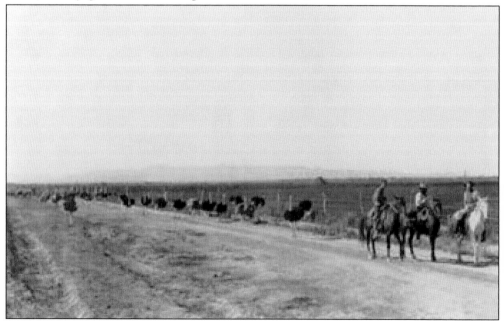

At the time, ostriches were raised for their feathers, which were fashionable decorations on ladies' hats. Feathers were quite profitable, with farmers reportedly receiving as much as $17 per pound even during poor economic years. The *Chandler Arizonan* newspaper reminded its readers not to pull feathers from the big birds, as that would ruin them. Rather, feathers should be clipped to ensure that they would grow back. At right, a hand steadies an ostrich in a specially designed pen to clip the feathers.

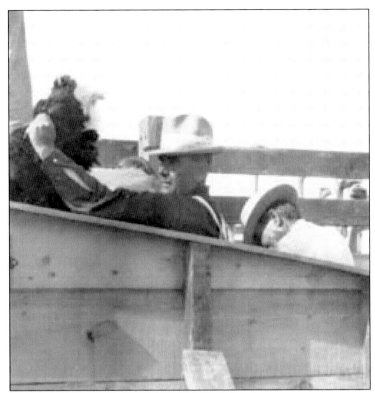

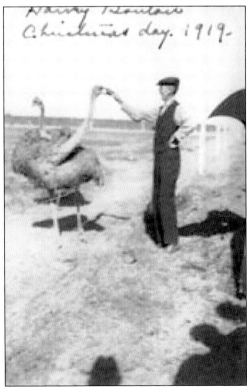

Ostriches created quite a spectacle in Chandler. Here, local farmer Harry Bouton takes a moment to feed one of the big birds during an outing on Christmas Day.

69

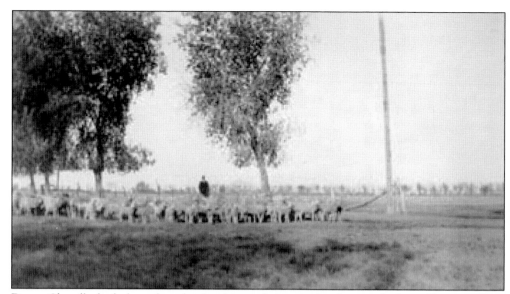

Doctor Chandler had a large sheep herd on his ranch, seen in the photograph above. Sheep ranching became a very lucrative business, and by 1934, other ranchers were raising more than 42,000 head in Chandler. Over two million pounds of wool were collected that year and sent to national markets. The largest sheep ranchers in Chandler included the Dobsons, Andersens, Morgans, the Chandler Improvement Company, and the Valley Bank & Trust Company. Immigrants from France's Basque region, such as the Etchamendy family, also raised sheep. The photograph below shows farmhands corralling Dobson sheep to load them onto railcars on their way to market.

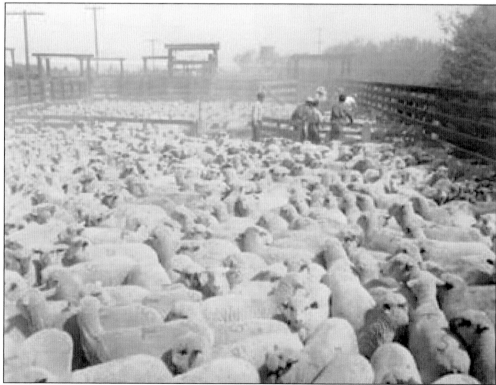

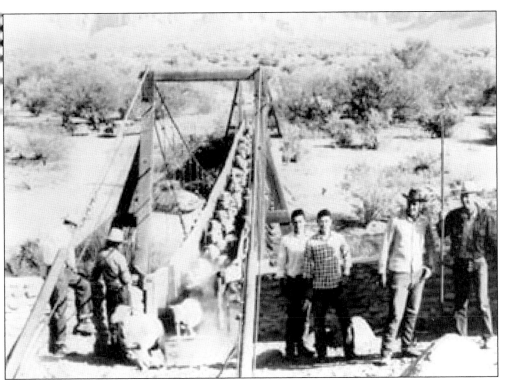

Ranchers would move sheep from the valley to the mountains for summer grazing in cooler climates to produce a better coat. The most popular route was the Heber-Reno Trail, which would take the sheep through 200 miles of Arizona wilderness on a 52-day trek. At the trail's end were large pastures at an elevation of 8,000 feet. The sheep herds reversed the trek back down to the Valley in the fall. Above, Dobson sheep cross the Blue Point Sheep Bridge on the Salt River, northeast of Chandler. The image below shows a sheep herd traversing a mountain stream during their trek.

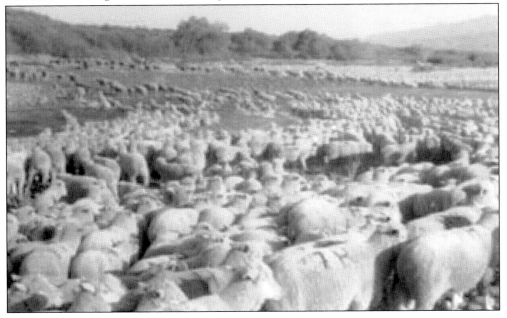

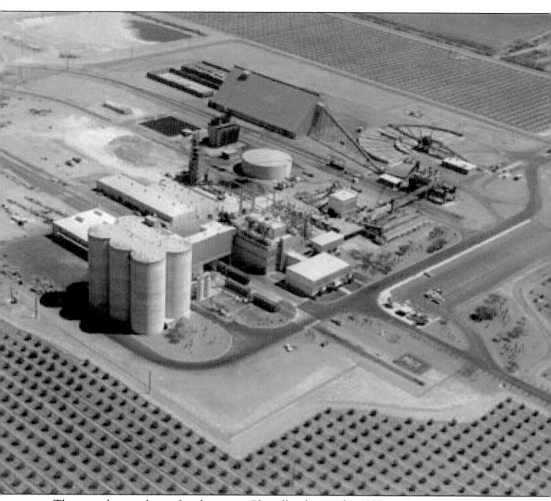

The sugar beet industry first began in Chandler during the 1930s and centered on raising seeds. The industry was revived in 1967 when the Spreckels Sugar Company opened on the northwest corner of McQueen and Riggs Roads. Its $20-million plant processed sugar beets into liquid sugar, primarily used in soft drinks and confections. Spreckels also produced a small amount of granular sugar for the local market. The plant closed in 1984 after the price of sugar beets hit rock bottom, the same year soft-drink manufacturers switched to using high-fructose corn syrup in their products. After the plant was demolished in 1999, the City of Chandler opened the Bear Creek Golf Course on the site.

Five

COTTON AND GOODYEAR

Cotton has been grown in the Salt River Valley for thousands of years. The Huhugam grew short-staple cotton, which they wove into textiles. The long-staple cotton that is still grown today was developed at the Sacaton Experimental Station in the early 20th century. This variety, known as Pima cotton, became an enormously profitable crop across southern Arizona. It was developed from the same strain of Egyptian long-staple cottonseeds that Doctor Chandler received from David Fairchild. Fairchild was charged by the US Department of Agriculture with traveling the world to find crops that could be grown in the newly reclaimed lands of the American West. While in Egypt, Fairchild collected long-staple cottonseeds, which he sent to Chandler to experiment with growing in Arizona. Doctor Chandler successfully grew the Egyptian long-staple cotton on his ranch, which eventually revolutionized the cotton industry. Long-staple cotton could be used in all sorts of products, from clothing to tires. Before long, farmers all over the Salt River Valley were planting the crop in massive amounts in the hopes of getting rich from it. World War I cut off the supply of Egyptian cotton, boosting the demand for Pima cotton. It was at this time that the Goodyear Rubber and Tire Company became interested in growing its own cotton on ranches in Arizona. Goodyear used cotton as radials in its tires, and Pima cotton was a perfect substitute for the Egyptian variety. The company leased 8,000 acres of land from Doctor Chandler four miles south of the recently settled Chandler townsite. The cotton market crashed in 1920, forcing Goodyear to consolidate its operations to the West Valley. Once the market stabilized, local farmers once again began growing Pima cotton. Though the market never returned to the heyday of World War I, cotton has remained an important cash crop for many Chandler farmers.

David Fairchild, a US Department of Agriculture employee, was responsible for finding crops that could be introduced into the American West. Among the foods he popularized were avocados, dates, grapefruits, cucumbers, onions, seedless grapes, and chickpeas. After an 1898 trip to Egypt, Fairchild sent back several different varieties of long-staple cotton. Some of these seeds he sent directly to Doctor Chandler. (Courtesy of Special Collections, National Agricultural Library.)

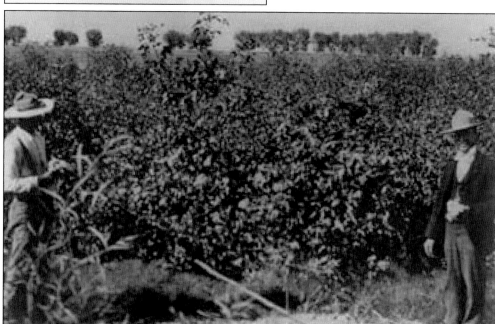

Doctor Chandler took these seeds and successfully grew Egyptian long-staple cotton on his ranch in Mesa by the late 1890s. In doing so, he proved that long-staple cotton could be grown in Arizona, which led to the development of an enormous commercial industry. In this photograph, Doctor Chandler stands at right with David Fairchild.

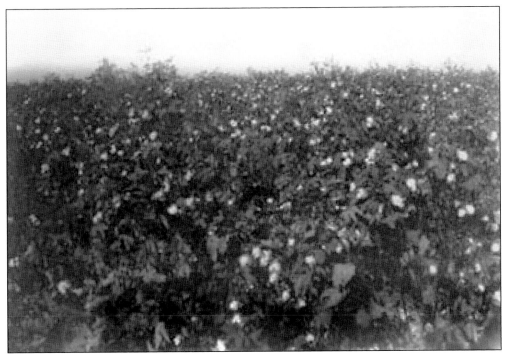

Experimentation with varieties of Egyptian long-staple cotton at the Sacaton Experimental Station led to the development of Pima cotton. Pima cotton is notable for its soft, long strands and is popular for its diversity of uses. These photographs show Pima cotton growing on the Lewis Ranch and the Chandler Improvement Company lands.

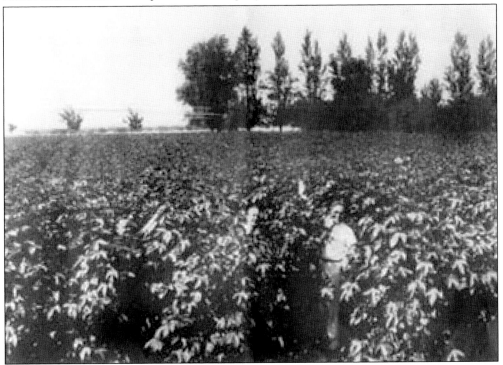

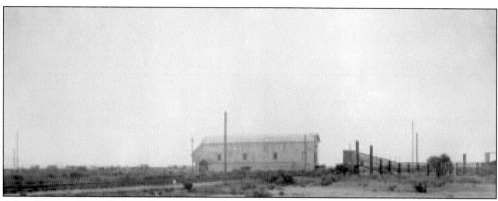

After Doctor Chandler's early success with growing cotton, many new settlers chose to plant cotton. Cotton gins sprang up all over the Salt River Valley. The Chandler Gin (pictured) was built in 1913. It was the first of a dozen gins that at one time operated in Chandler.

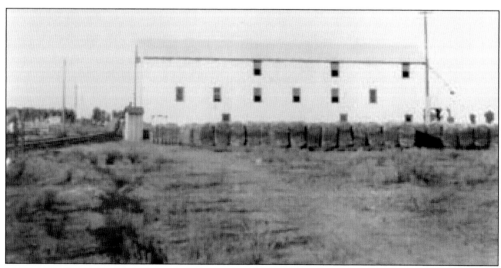

Cotton production grew exponentially in the 1910s. Farmers in the Salt River Valley planted 200,000 acres of cotton in 1920. In this picture, row after row of baled cotton waits to be loaded onto freight trains outside the Chandler Gin.

Cotton production involved many steps, including planting, thinning, picking, stomping, and ginning. Since picking cotton required a huge workforce, people of all ages were employed as pickers. Right, Horace Gilbert and Robert Mitchell take a moment to pose for a picture with their full cotton bags. Below, Clemente Torres heads to the fields, cotton bag in hand.

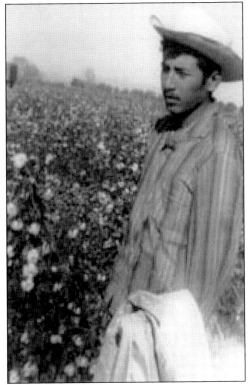

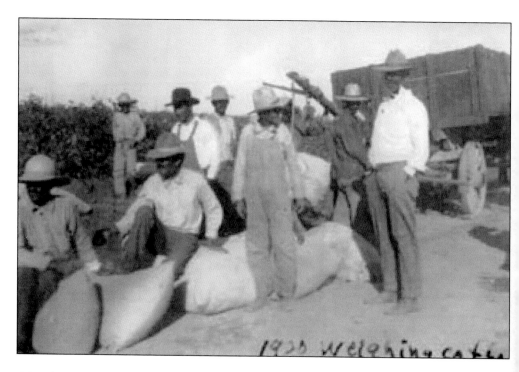

After the cotton was picked it needed to be weighed. Workers were paid according to how many pounds of cotton they were able to pick. Above, unidentified pickers wait to weigh their bags filled with cotton picked that day. Below, a truck carrying bags stuffed with cotton prepares for a trip to the cotton gin.

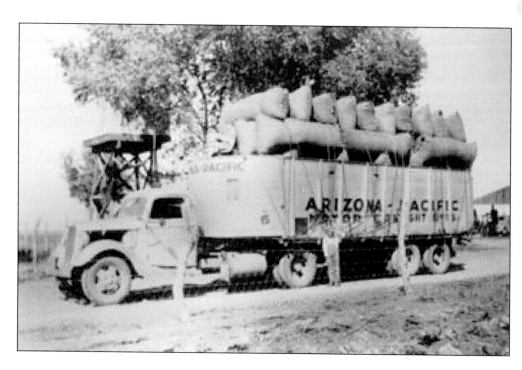

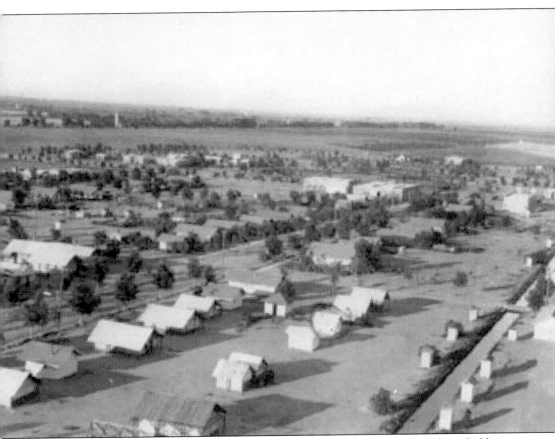

In 1917, when access to Egyptian cotton was cut off during World War I, the Goodyear Rubber and Tire Company looked to Arizona as a source of cotton. The company used cotton as a foundation to strengthen the rubber in its tires. The company leased land from Doctor Chandler in order to start its own cotton ranch. This aerial photograph shows the settlement of Goodyear located on 8,000 acres four miles south of the Chandler townsite. The ranch covered roughly 12 square miles, from today's Hunt Highway to Ocotillo Road and from McQueen Road to Price Road. Goodyear spent more than $1.5 million in improvements to the land, including developing a town. This company town provided workers with everything they needed, including housing, medical care, schools, shopping, and entertainment. The cotton market crashed in 1920, forcing Goodyear to sell off its interests near Chandler and consolidate its Arizona operations in to the West Valley.

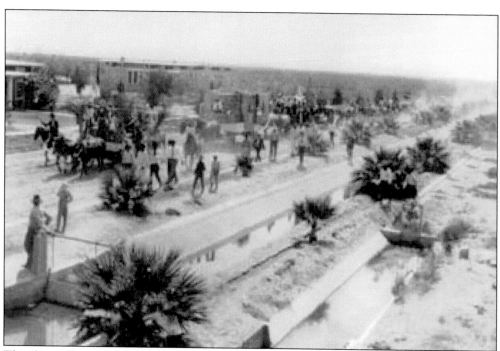

The above photograph, which looks southeast from the center of Goodyear, shows a parade on the main street in Goodyear, now Basha Road. Palm trees lined the irrigation canal that divided north and south traffic on the street. The cotton fields, which started on the edge of town, extended several miles in every direction. The image below shows the Goodyear School. It was made up of four one-room schoolhouses that served the children of the families working the Goodyear cotton fields.

As in company towns across the nation, Goodyear intended to provide all services for its employees. In the picture above, the structure at center is actually two buildings divided by a breezeway. The building on the right is a pool hall, and the one on the left is a grocery. The Bashas' grocery chain was later begun in this building, which now houses the corporation's headquarters. In the distance at the far left, a movie theater is barely visible behind the trees. Below is the Goodyear hospital.

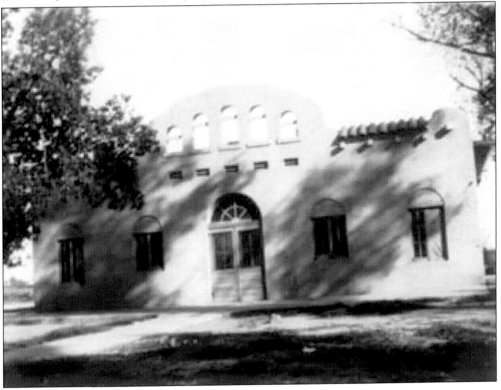

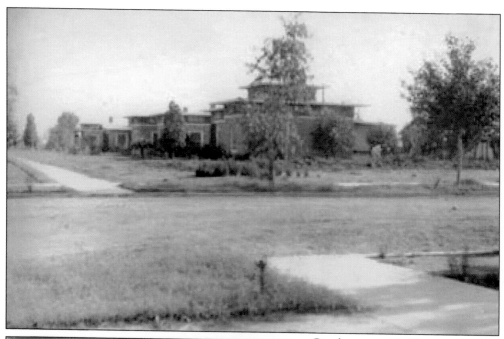

Goodyear provided housing for its employees. Executives and managers were given housing in neighborhoods with cement sidewalks, well-manicured lawns, and beautifully landscaped yards like the one pictured above. Mexican and Yaqui laborers who came to Goodyear to work in the cotton fields were provided with low-slung adobe barracks like those pictured left.

Six

FRANK LLOYD WRIGHT AND A NEW VISION FOR CHANDLER

Doctor Chandler and Frank Lloyd Wright met in 1928 while Wright was in Phoenix consulting on the construction of the Arizona Biltmore Hotel. Chandler approached Wright with an idea for a grand hotel on land he owned in present-day Ahwatukee. The two met at a time when Wright was struggling financially and was willing to visit the site Doctor Chandler described. After exploring the desert location, Wright eagerly accepted the commission to plan a large hotel called the San Marcos in the Desert. He set up camp with his team and family at the site the following winter, calling the camp Ocatilla, an intentional misspelling of the ocotillo plant that grew in abundance on the site. Despite the finished plans for the hotel, the stock market crash in October 1929 forever doomed its construction. In addition to the San Marcos in the Desert and camp Ocatilla, Wright and Chandler planned several other local projects. These included the San Marcos Water Gardens resort, the Little San Marcos in the Desert, a redesign of the San Marcos Hotel, houses for Owen D. Young, Wellington and Ralph Cudney, and Doctor Chandler, a camp at Chandler Heights Citrus Tract, and the Chandler block house. These efforts amounted to a complete redesign of the town along Wright-inspired principles. The only projects ever realized, however, were the construction of Ocatilla and the camp at Chandler Heights. In 1935, Wright decided it was time to return to Arizona with his architecture students. Doctor Chandler offered housing for them in La Hacienda, a former polo stable converted into a hotel. Wright and his students spent two winters at La Hacienda in Chandler, spending most of their time developing the model of Broadacre City, Wright's concept of suburban planning. Wright was so inspired by his time in Chandler and his experience in the desert that he decided to build his home and architecture school in the foothills of the mountains in Scottsdale, on a site reminiscent to that of the San Marcos in the Desert, called Taliesin West.

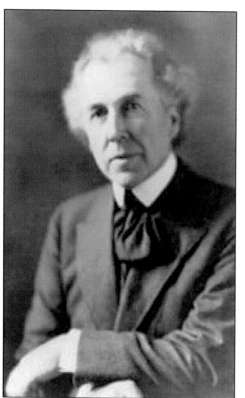

Acclaimed architect Frank Lloyd Wright met Doctor Chandler in 1928 while Wright was consulting on the construction of the Arizona Biltmore. Chandler first approached Wright with an idea for a grand hotel to be built at the base of South Mountain. Wright was receptive, partially because of his poor financial state, but also because he was impressed with Chandler, believing him to be a man of vision. (Courtesy of the Frank Lloyd Wright Foundation.)

Chandler took Wright to the proposed site for the hotel on the southern slope of South Mountain. What is now home to housing developments was open desert, elevated in the foothills with sweeping views of the desert floor below. Upon seeing the site, Wright said "There could be nothing more inspiring to an architect on this earth than [this] spot of pure Arizona desert . . . at last here was the time, the place, and in Doctor Chandler the man." Here, Frank Lloyd Wright is pictured with his wife, Olgivanna, and their daughters Svetlana and Iovanna at his base camp at the hotel site. (Courtesy of the Frank Lloyd Wright Foundation.)

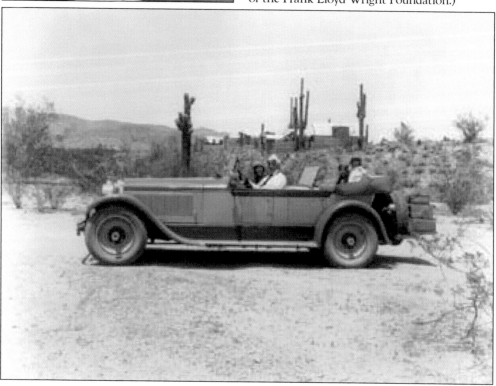

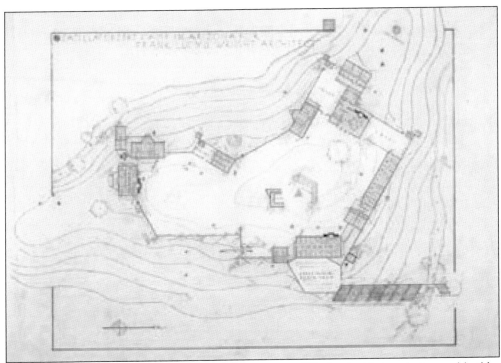

Rather than pay to house his entourage in apartments, Wright decided to design and build a camp for the winter as he planned the new hotel. The camp, named Ocatilla, was located at the hotel site. Wright designed the camp himself in a day, and the small buildings, modeled on tent houses, were erected within a few more days. The structures had low wooden walls with canvas roofs angled to catch the desert sun and harmonize with the mountain landscape. Wright likened the camp to a fleet of sails on the desert, and photographs like the one below were published in architectural journals worldwide. Wright's team built the camp in January 1929 and lived there through May. By the end of their stay, the Midwesterners were dealing with Arizona heat, rattlesnakes, tarantulas, and scorpions and were ready to leave Ocatilla. (Both, courtesy of the Frank Lloyd Wright Foundation.)

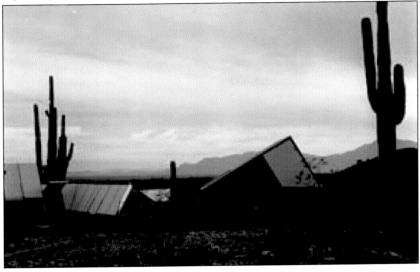

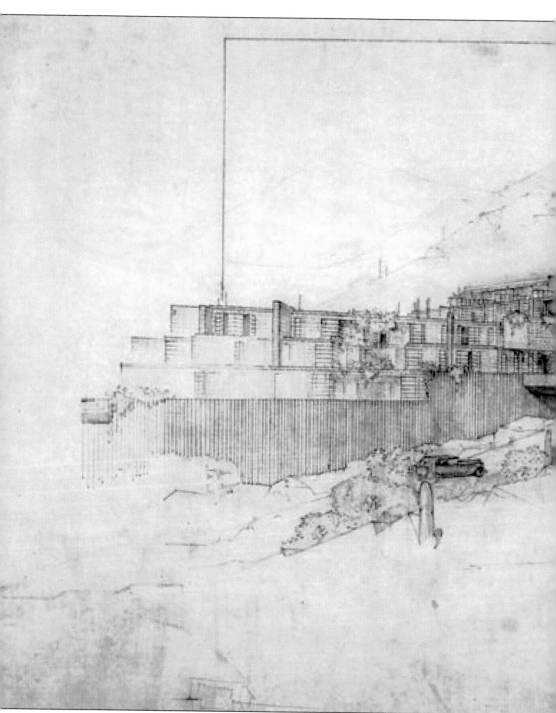

The monumental San Marcos in the Desert was to offer beautiful views of the desert spreading out below. Located on 1,400 acres in the South Mountain foothills, the hotel was to be built into the side of the mountain, with three terraced floors of guest rooms on each wing. Guests were to drive underneath the main lobby of the hotel following the course of a ravine. In addition to the structural blocks, glass blocks were to be used to allow in natural light. The geometric design of

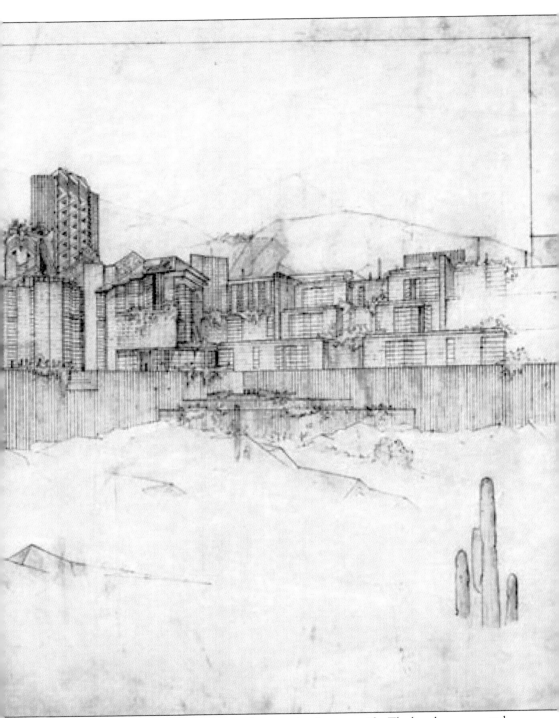

the building was meant to encourage guests to focus on the desert outside. The hotel was accented in copper and glass with repeated geometric shapes. Each guest suite had two bedrooms and two bathrooms. Every bedroom was to be adorned with a large tapestry woven in a pattern to match the architecture. Since the hotel was terraced, the roof of each level served as a garden for the level above. (Courtesy of the Frank Lloyd Wright Foundation.)

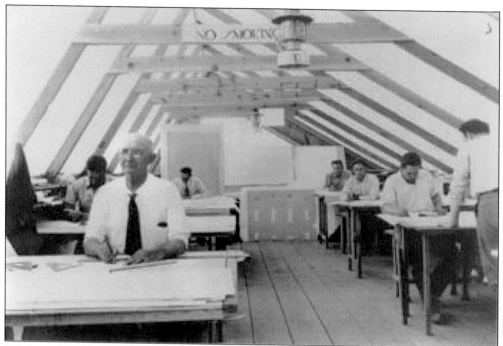

While at Ocatilla, Wright's draftsmen worked on drawings for the new hotel, which was to be named the San Marcos in the Desert. The draftsmen worked in buildings furnished with canvas chairs, cots, and Navajo rugs. Here, men work on the drawings for the hotel. "Cueball" Kelly, in the foreground at left, stares thoughtfully into the distance. (Courtesy of the Frank Lloyd Wright Foundation.)

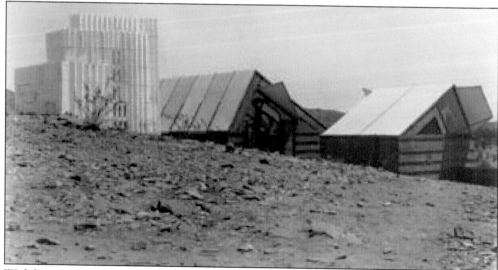

With his newest project, Wright wanted to correct what he saw as a flaw of the Arizona Biltmore. The Biltmore used textile blocks as a facade. Wright felt that the textile blocks should be structural and endeavored to design his new hotel that way. Structural textile blocks were considered radical, so to demonstrate this idea Wright's team built a plaster mock-up structure at Ocatilla (pictured). The blocks for the San Marcos in the Desert were inspired by the ribs of a saguaro cactus. (Courtesy of the Frank Lloyd Wright Foundation.)

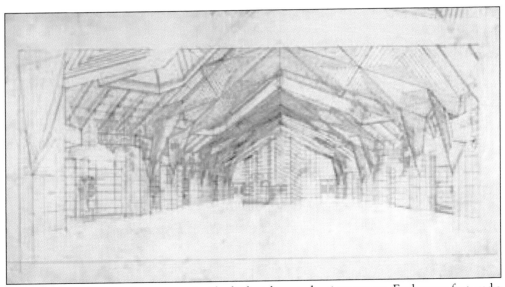

Irregular-shaped triangular patterns inside the hotel created unique spaces. Each room featured a large fireplace on the western wall. The ceiling at the highest point in the hotel reached 20 feet. The ceiling in the dining room was decorated in copper, and its terraced levels were made to look like an arbor. Skylights pierced the ceiling throughout the center rooms of the hotel. (Courtesy of the Frank Lloyd Wright Foundation.)

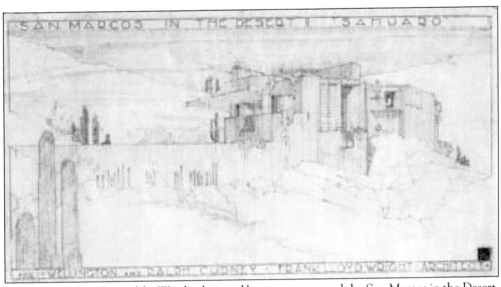

Doctor Chandler planned for Wright-designed houses to surround the San Marcos in the Desert. One of these was a house designed for Wright's friends Wellington and Ralph Cudney. The Cudney House was modeled after the center section of the San Marcos in the Desert. It was a two-story house, with living rooms on the bottom floor and bedrooms on the top floor. It was to be built of the same textile and glass blocks as the hotel. (Courtesy of the Frank Lloyd Wright Foundation.)

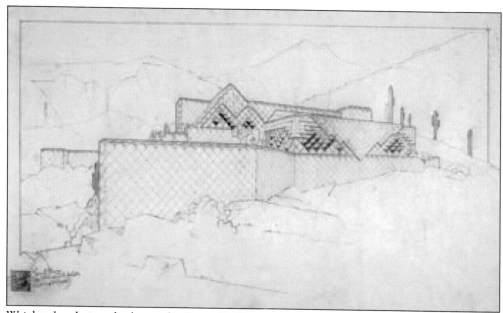

Wright also designed a house for Owen D. Young, one of Chandler's business partners and a confidant of Pres. Woodrow Wilson. The Young House was based on the wings of the San Marcos in the Desert. It was dominated by a large solarium overlooking the desert. (Courtesy of the Frank Lloyd Wright Foundation.)

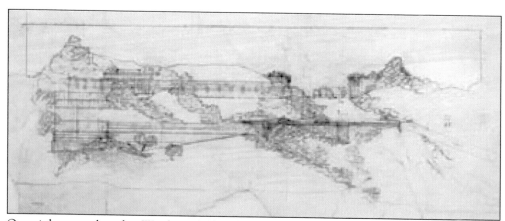

Once it became clear that Wright and Chandler would not be able to procure the money needed to build the San Marcos in the Desert, they planned for a smaller hotel. The new resort plan featured many of the same design aspects of the larger hotel but was to be located in the foothills of the San Tan Mountains. Called the Little San Marcos in the Desert, this project, too, never came to fruition. (Courtesy of the Frank Lloyd Wright Foundation.)

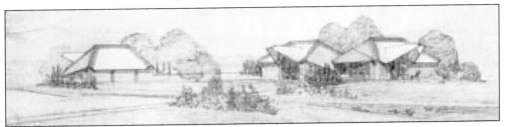

Another Wright project, the San Marcos Water Gardens, was to be located in the center of Chandler. The Water Gardens was to be a resort based on the Ocatilla camp. A series of cabins with concrete walls and roofs of wood and canvas stood on the banks of a minor system of canals reminiscent of Chandler's irrigation network. A larger building would house a dining room, kitchen, and lounges for guests. Doctor Chandler wrote to Wright explaining his disapproval of the canvas roofs, to which Wright responded "The fact is that only by the use of the canvas can we get that translucence inside that seems to belong to Arizona sunshine . . . There is nothing that could give this effect but canvas or some similar fabric." (Courtesy of the Frank Lloyd Wright Foundation.)

Viewed from above, the San Marcos Water Gardens featured small networks of canals flowing in a geometric layout. Private cabins were available for both married and "bachelor" visitors. (Courtesy of the Frank Lloyd Wright Foundation.)

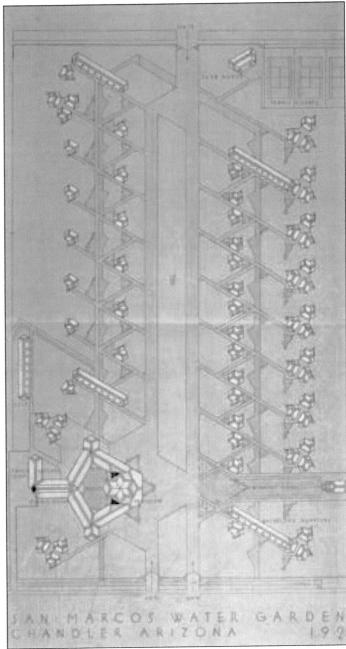

SAN MARCOS WATER GARDEN
CHANDLER ARIZONA 192

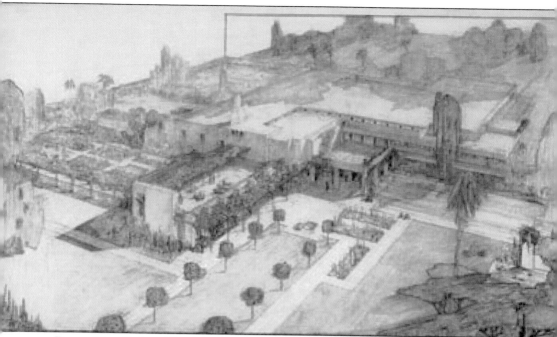

Doctor Chandler's and Frank Lloyd Wright's plans for the town of Chandler called for a reinvention of the town. This necessitated the redesign of the San Marcos Hotel, despite the fact that the hotel was only 23 years old. Doctor Chandler allowed Wright to re-envision what the hotel could look like. Wright did not care for the Mission Revival style of the hotel, and his new plans for the resort reflected his own aesthetic. This sketch is of the view northeast toward the back of the San Marcos. (Courtesy of the Frank Lloyd Wright Foundation.)

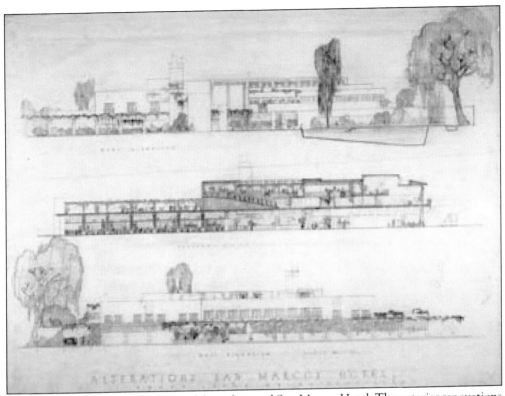

The sketch above is a cross section of the redesigned San Marcos Hotel. The exterior renovations featured the typical Frank Lloyd Wright–style lines and low profiles. The inside boasted monumental architecture and atypical angles that created unique geometric spaces. The sketch below shows the plan to redesign the San Marcos Hotel's dining room. (Both, courtesy of the Frank Lloyd Wright Foundation.)

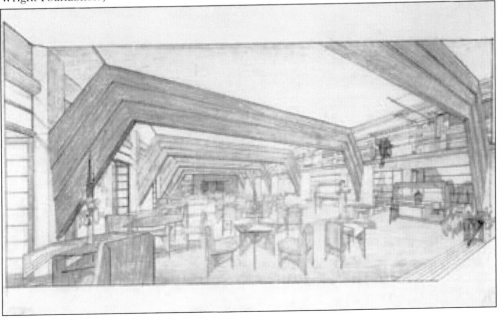

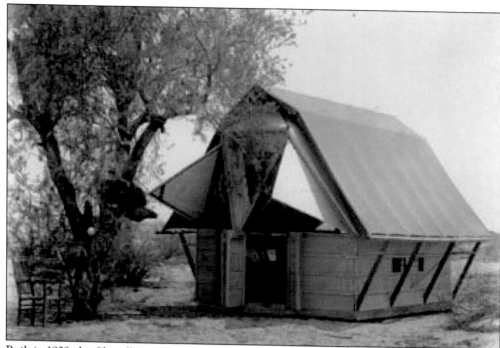

Built in 1929, the Chandler Heights Citrus Camp was one of only two projects Frank Lloyd Wright ever completed in Chandler. The camp was made up of a dozen unique buildings made of wood with canvas roofs. In addition to housing the camp manager, workers, and visitors, it also had a recreation hall, a dining hall, and a kitchen. Despite being far from the center of Chandler, the camp was electrified. (Above, courtesy of the Frank Lloyd Wright Foundation; below, courtesy of Brian A. Spencer, AIA.)

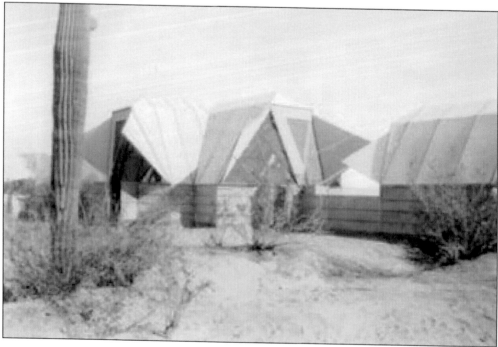

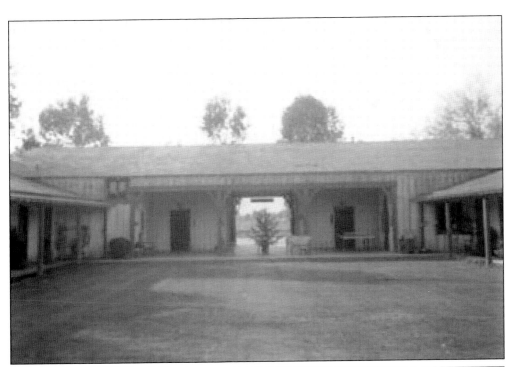

In the winter of 1935, Frank Lloyd Wright was looking to return to Arizona. Wright's wife, Olgivanna, disliked Wisconsin, and Wright himself fondly remembered his winter at Ocatilla. He began searching for places in Arizona to spend the winter with his architecture students. Doctor Chandler offered Wright housing in La Hacienda, a structure originally intended as polo stables but converted into a hotel. La Hacienda suited Wright because it offered ample room and outdoor space for him and his students to work. They spent the winters of 1935 and 1936 at La Hacienda before moving to their new home at Taliesin West in Scottsdale. The photograph above is of the entrance and courtyard of La Hacienda. The diagram right shows the layout of La Hacienda and its location in Chandler.

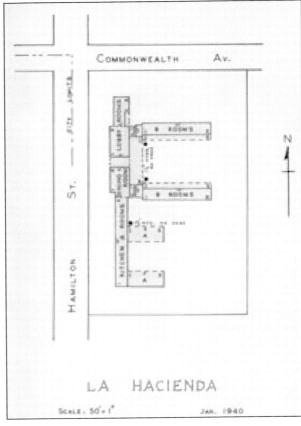

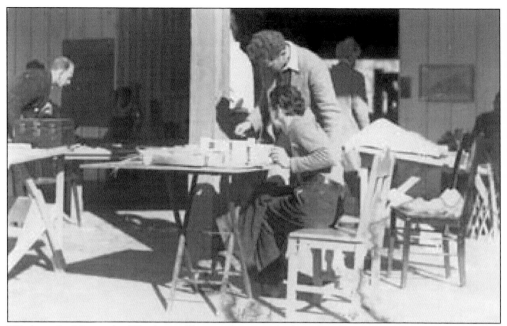

While at La Hacienda, Wright and his students worked on developing the model for Broadacre City, which demonstrated Wright's concept of the ideal suburban development. Wright's vision called for families to be given an acre of land on which they would subsist. Urbanization and mass transit were scaled back so as to be almost nonexistent. The automobile was emphasized, with a grid of arterial streets and superhighways connecting commercial development zones. Students in the photographs above and below work on a 12-by-12-foot scale model that represents the four-square-mile community. Wearing a beret, Frank Lloyd Wright is visible leaning over the model in the photograph below. (Both, courtesy of the Frank Lloyd Wright Foundation.)

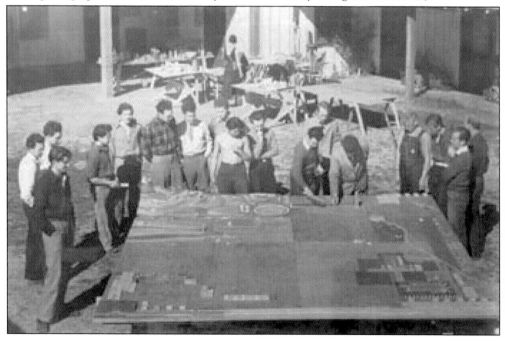

Seven

WILLIAMS AIR FORCE BASE AND WORLD WAR II

After the attack on Pearl Harbor, Chandler residents rushed to help with the war effort, and more than 500 of the town's 1,300 residents eventually served. Some even left high school to enlist. Those left at home helped with victory gardens, scrap metal and bond drives, and by filling the void left by those who enlisted. To remember those serving, the community erected an honor roll of the names of everyone serving from the Chandler area. The war effort expanded locally when the military established a pilot-training facility just east of Chandler. Williams Air Field, affectionately known as Willie, was constructed by famed housing developer Del Webb for $1.5 million. When the base opened in October 1941, the PX (the commissary) had one case of soda, one carton of cigarettes, and a few candy bars. Willie offered few other amenities. The officers and enlisted men had to travel eight miles to Chandler to bathe, and they had to carry drinking water from two miles away. Despite these inauspicious beginnings, Williams Air Field grew to be one of the largest pilot-training facilities in the country during the war. Thousands of people moved to Chandler because of the base, including both civilians and military personnel. Because it was the closest town, those stationed at the base would travel to Chandler to bank, shop, watch movies, and socialize with community members. After the war, the facility, renamed Williams Air Force Base, continued to grow. Williams began training jet pilots in the late 1940s, and this continued until the base closed. In the 1970s, it graduated the Air Force's first class of female pilots. The ties between Chandler and Williams were strengthened when the Air Force donated an F-86d fighter jet that had flown over Korea to be displayed in Chandler's downtown. Williams Air Force Base closed in 1993 and is now the site of Phoenix-Mesa Gateway Airport. The long relationship involving World War II, Chandler, and Williams Air Force Base changed the face of the community and set Chandler on the long path to growth.

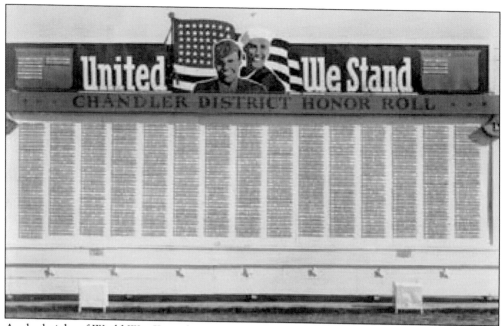

At the height of World War II, as the United States was island hopping in the Pacific Theater, and the Allies were invading Italy, Chandler residents constructed a memorial to their friends and family serving in the military. Located in the downtown park, the memorial featured the names of everyone from Chandler and the surrounding areas serving in the war effort. At the dedication to the memorial, the *Chandler Arizonan* remarked that "For those whose names will appear on the Roll of Honor, it will carry the assurance that the community will continue its support of the war effort—and their names will be proof that their home town will not forget them—ever."

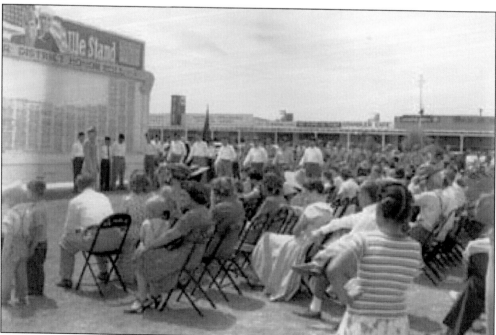

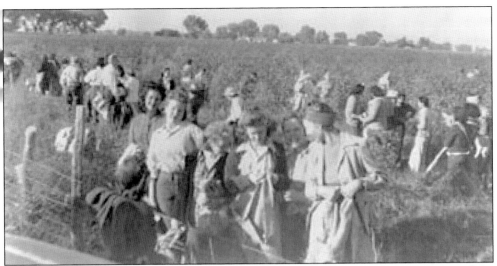

Chandler residents who did not go to war still supported the war effort. Across the nation there was a major labor shortage because most able-bodied men served in the war. This shortage meant that a new workforce had to be found. Chandler High School contributed its students to the workforce during cotton harvest by releasing them to pick cotton. The above photograph was taken during the cotton harvest of 1943.

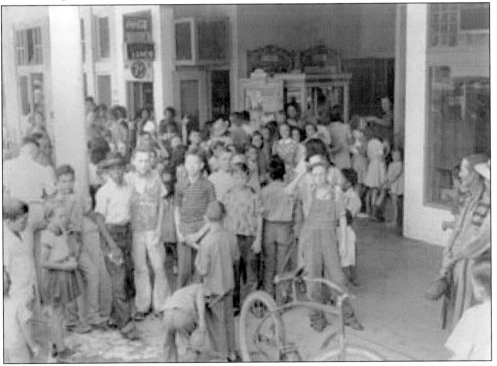

New military equipment, including ships, tanks, planes, and weapons, required massive amounts of metal. While metal was being rationed, people were encouraged to recycle their excess metal items at scrap drives. Individuals and organizations organized these drives in their towns across the country. In the one pictured here, Joe and Alice Woods offered a free movie at the Rowena Theater to children who donated their scrap metal.

Corley Haggarton was one of the many Chandler residents who enlisted in the military during the war. He joined the Navy while a junior in high school. In San Diego, Haggarton taught sailors to swim. Later, he drove LCVP (landing craft, vehicle, personnel) and LCM (landing craft, mechanized), while as part of a salvage unit. For the remainder of his service, he was deployed to Guam, where he supplied ships in the harbor.

When Haggarton returned to Chandler after his enlistment was up, he, like others who had left high school to enlist, went back to school and graduated. Here, Haggarton proudly poses while wearing his cap and gown.

Ernie Karkula grew up herding cattle. In 1943, when he was 18, he enlisted in the Marine Corps. After basic training, he was sent to Guadalcanal, where he prepared for future island invasions and learned to use a BAR (Browning Automatic Rifle). Karkula landed in the first wave of invasions at Guam and Okinawa and survived both historic battles. Karkula returned to Chandler and later became an officer in the Chandler Police Department.

After Pearl Harbor, Noel Addy volunteered to pilot gliders in the Army Air Corps. Addy was sent to England to prepare for the Normandy invasion. On D-Day, he guided his glider full of machine gunners behind the German lines and crashed into a hedgerow. Addy went into battle with the soldiers and fought his way back to the beaches over the course of three days. He later participated in Operation Market Garden and the crossing of the Rhine River in Germany. Noel Addy took this photograph of glider pilots in training.

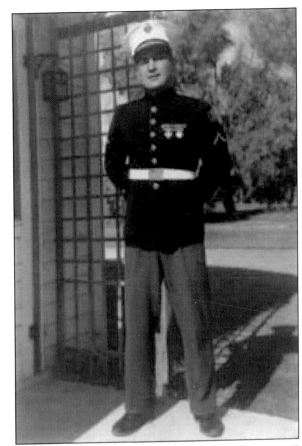

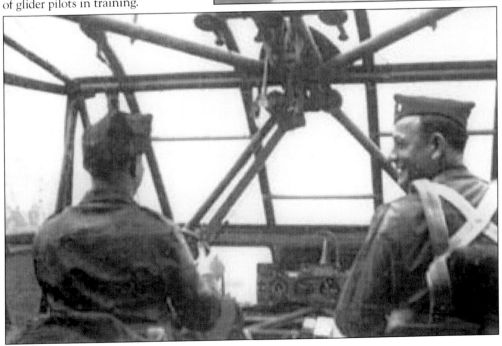

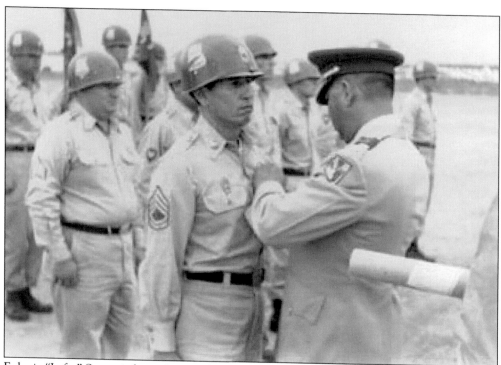

Eulogio "Lefty" Soto tried to volunteer for the Army after Pearl Harbor, but he was turned away because he was too young. Soto was drafted for service in the Army in 1943 and was shipped out to New Guinea. From there, his unit was sent to the Philippines, where it spent six months fighting the Japanese. Soto then was stationed in Kyoto as a member of the Army of Occupation after the Japanese surrender. The photograph below, taken by Soto, shows the destruction in Kyoto after repeated bombing by the United States. For his service, Soto was awarded the Bronze Star, which he receives in the image above.

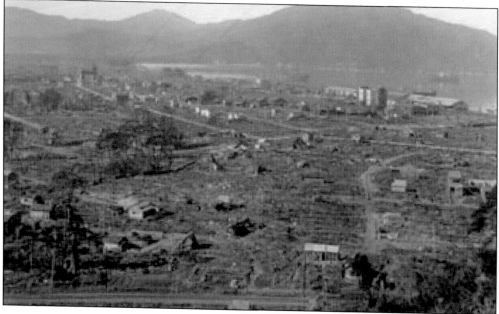

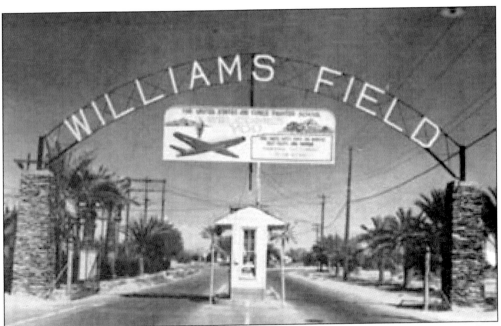

Williams Field, later Williams Air Force Base, opened in 1941 to train US Army Air Corps pilots. It was located eight miles east of downtown Chandler. Soon after the base opened, the United States entered World War II, and Willie, as it was known, produced nearly 10,000 pilots, including actor Jimmy Stewart. (Courtesy of Phoenix-Mesa Gateway Airport.)

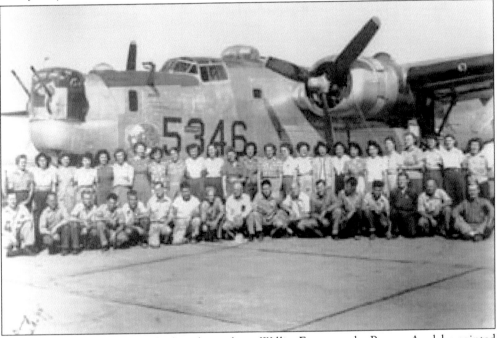

Many Chandler residents worked civilian jobs at Willie. For example, Barney Appleby painted planes, and Marie Haggarton worked in the telephone exchange. In this photograph, members of the civilian workforce at Willie pose in front of a B-24 Liberator on the base during World War II.

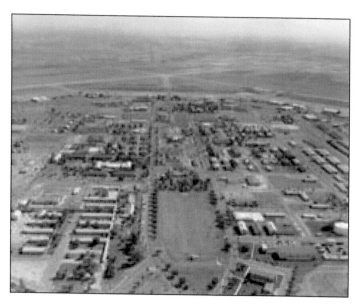

Williams Air Force Base was named for Lt. Charles Williams, an Arizona pilot who died in a plane crash in 1927. The light winds and flat topography of Chandler's desert location provided an ideal environment for flight training. The location was particularly attractive during the war because the inland location offered security from foreign attack. These conditions combined to make Willie one of the largest pilot-training facilities in the country.

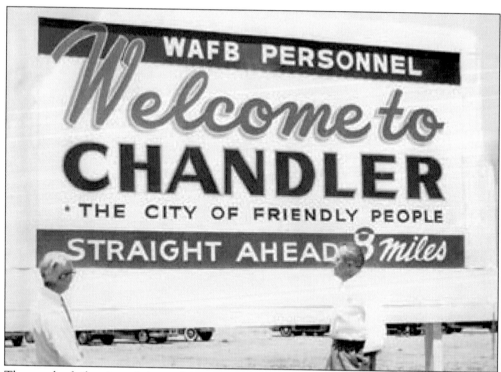

Thousands of pilots-in-training and their families lived in Chandler. The proximity of the base to the city brought an economic boom for Chandler. Neighborhoods sprang up, and new businesses opened. The downtown flourished as the nearest commercial development to the base. The Air Force used Chandler's Valley National Bank to distribute payroll, encouraging people to spend their money in Chandler.

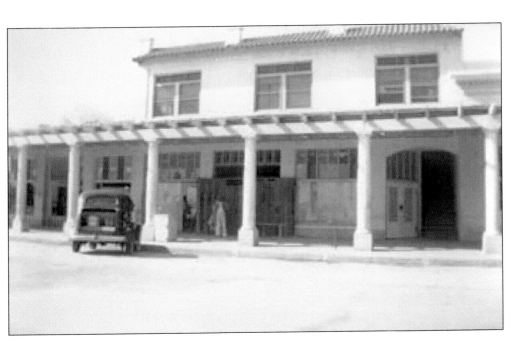

During World War II, a USO opened in downtown Chandler. The USO was heavily used by pilots from Willie, but there was still demand for a second movie theater. Joe and Alice Woods, owners of the Rowena Theater, bought a building in downtown and converted it to the Parkway Theater. Because building supplies were only available for the war effort, the Woods applied for and were awarded a special grant through the USO to convert the building. The photograph above shows exterior renovation work being done to the building. In addition to having to build a screen, a projector booth, and install seating, workers had to excavate the floor to create a slope. The photograph below shows interior work being done to the building with a dump truck visible in the darkness in the background.

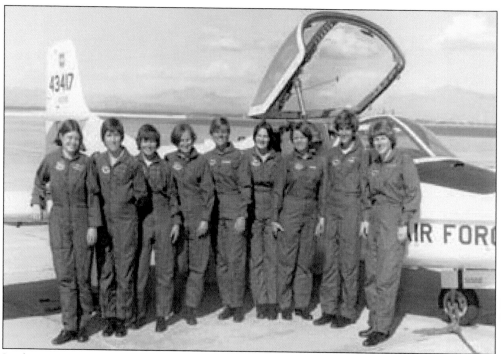

In the post–World War II era, Willie went through several changes. After the Air Force was officially created in 1947, Williams Field was renamed Williams Air Force Base. Williams became the first jet pilot–training base in 1949. In September 1977, the first women to complete pilot training in the country graduated from Williams. That first class of women is pictured.

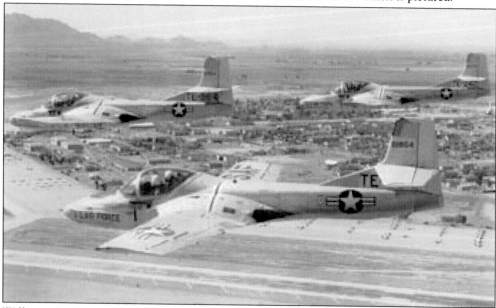

Williams Air Force Base closed in 1993. Over the course of its 52 years as an Air Force pilot-training facility, Willie produced more than 25,000 pilots and thousands of bombardiers and navigators. At the time it closed, Willie was estimated to have employed over 3,800 people and had an economic impact of more than $300 million annually.

Eight

A COMMUNITY
OF ORGANIZATIONS

The heart of any community is its organizations. Chandler has a rich history of groups working to improve the community, serve residents, encourage civic engagement, and care for children. Some were short-lived, while others have served the community for 100 years. National clubs made their mark in Chandler, while homegrown organizations came together to confront local issues. The Lions Club, the Rotary Club, the Rotary Anns, the American Legion, the American Legion Auxiliary, the Veterans of Foreign Wars, the VFW Auxiliary, the Weeders Garden Club, the Philanthropic Education Organization, the Optimists, the Elks Club, the Toastmasters, the Moose Club, Altrusa, the Odd Fellows, the Rebekahs, the Woodmen of the World, the Masons, the Kiwanis Club, the Knights of Columbus, and the Boy and Girl Scouts all have or have had chapters in Chandler. An entire book could be dedicated to the work of these and countless other groups that have not been mentioned. What follows are just a few of the many organizations that have made Chandler a better place to live.

Chandler's first law enforcement agency, organized in 1920, consisted of a town marshal and watchmen. In 1948, they received their first official uniforms, though they had to pay for the uniforms, gun belts, and weapons themselves. This picture shows the first "police force" in 1950. They are, from left to right, watchmen Carrol Bollinger, James Watson, Joe Love, Jack Boyer, and Town Marshal Roy Wolf.

Chandler's law enforcement was reorganized in 1951, and Chandler's modern police department was born. The Chandler Police Department has continued to grow, and today it employees 500 people and has three stations across the city. This photograph shows the entire department around 1963 showing off their new tan uniforms. Pictured in the front row on the left is Ramona Ruiz, Chandler's first female police officer.

The Chandler Fire Department was officially organized as a volunteer outfit in 1937. One of the first things purchased for the new department was a 1936 Dodge pumper truck, pictured here. Posing with the pumper are, from left to right, Mayor J.W. Sinks and Councilmen Bert Hill, Mark Stowe, and J. Lee Loveless. The 1936 Dodge pumper is still used today by the Chandler Fire Department for parades and ceremonies.

The Chandler Fire Department grew to have a paid chief and two paid captains in 1953. By 1970, the entire department was staffed by personnel on the city's payroll. The department today has grown to more than 200 firefighters with 10 fire stations throughout the city. In this undated photograph, Chief George Knight and several members of the Chandler Fire Department pose with a Maytag dryer for a promotion.

The Chandler Chamber of Commerce was first organized in 1912 by Doctor Chandler and his associates. The chamber's initial role was as a booster for the new town of Chandler, and its members hosted meetings and speakers, published articles in local newspapers, and travelled the country promoting Chandler. This promotional work continues today, as the Chandler Chamber of Commerce works to bring new businesses and create a strong commercial network in the community.

The Chandler Junior Chamber of Commerce (Jaycees) was an organization for young, business-minded Chandlerites. The Jaycees operated the Chandler swimming pool on the northwest corner of Frye and McQueen Roads. Members of the club, including club president Floyd Bouton, are pictured at a Jaycees event in 1923.

The Chandler Woman's Club was one of the first organizations for women in Chandler. It was organized for them to be able to do community service and for social events. This photograph was taken at a Woman's Club costume party in 1950. Among those pictured are Ann Crawford, Jeanette Murphree Smith, and Rosa Chandler, Doctor Chandler's third wife.

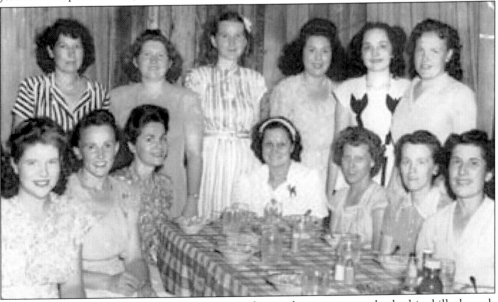

The Chandler Junior Woman's Club was organized to teach young women leadership skills through community projects. Club members pictured here include Peggy Joiner, Pauline Openshaw, Hazel Guptil, Jean Pew, Carmen Serrano, Zona Shepherd, Daisy Mosley, Dorothy Gleason, Margaret Lapp, and Rosalina Bernard.

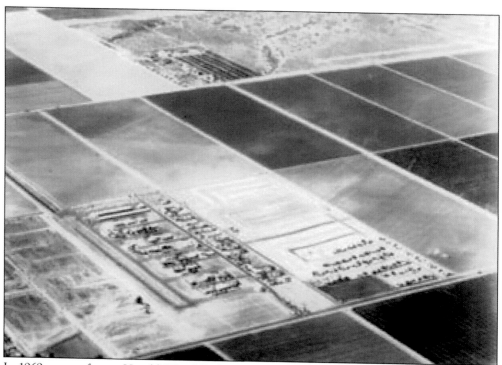

In 1969, cotton farmer Harold "Tom" Earley Jr. developed Stellar City Airpark. Surrounded by agricultural land, it was planned to have 80 homes, hangars, a wash rack, maintenance hangar, fueling station, and motel. Earley died in a plane crash in 1975 before his dream had come to fruition. In 2000, Mark-Taylor added 65 lots in the gated Stellar Airpark Estates. In the following decade, two renovations improved the safety of the airport. The second upgrade was completed in an amazing 100 days. The remaining empty land was developed as Stellar Estates II. Some 43 years after Earley's original plan, Stellar Airpark is one of the finest airparks in the country and is definitely a gem in the city of Chandler.

The Chandler Municipal Airport was first dedicated on March 13, 1928. Gov. George W. P. Hunt dedicated the airport by saying, "I desire to congratulate the progressive citizens of Chandler on their good sense and foresightedness in providing a municipal airport at this time." Shown here, Hunt's successor John C. Phillips rededicated the Chandler airport at its new location in 1929.

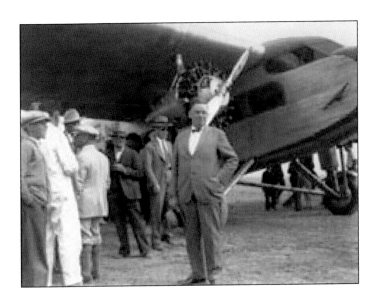

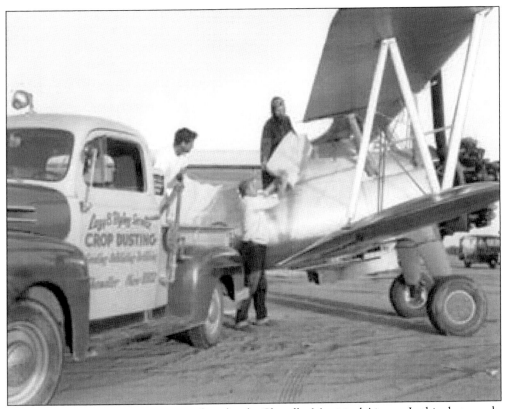

Crop dusting was an important activity based at the Chandler Municipal Airport. In this photograph, the Lazy 8 Flying Service loads crop-dusting powder into a plane at the airport. Robert "Tug" Wachs purchased Lazy 8 Flying Service in 1954 and converted what was a flying school into one of the largest crop-dusting fleets in Arizona.

In 2003, Bryan Lambke and his father, Tom, won the gold medal in unified bowling at the Special Olympics Summer World Games. Upon their return, they helped to form Recreation and Athletics for the Disabled (RAD) in partnership with the City of Chandler. RAD offers financial assistance to any Special Olympics athlete who needs it. In December 2007, Bryan was inducted into the Chandler Sports Hall of Fame for his Special Olympics accomplishments.

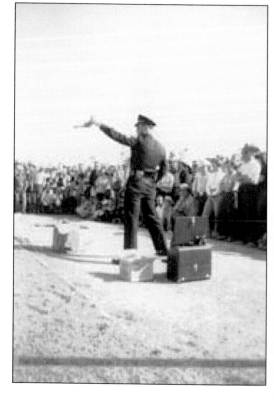

The Chandler Rod and Gun Club met in a clubhouse on the grounds of Chandler Municipal Airport. The club held several events every year, including a popular buffalo barbecue, a varmint-calling contest, and shooting exhibitions like the one pictured.

The Chandler Historical Society was organized in 1969 by Billy Speights and Bert Cummings. The group worked actively to preserve Chandler's history. In 1972, members opened the Chandler Museum. Since that time, the historical society has worked diligently to share Chandler's history with the community and advocate for a new museum facility. Pictured, left to right, are board members Julia Hall, Palmer Boberg, Audrey Ryan, and Alice Woods.

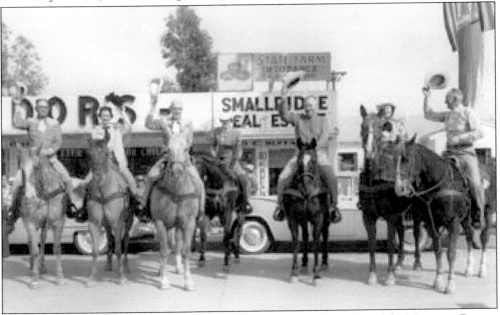

The Chandler Sheriff's Posse was organized in 1955 as an auxiliary arm of the Maricopa County Sheriff's Department. Starting in 1956 and continuing in later years, the Chandler Sheriff's Posse became a sponsor of the nationally known Chandler Rodeo. The Chandler Rodeo began in 1935, when it was sponsored by the Western Tavern. The Posse lives on today as the Chandler Mounted Posse and continues to hold events.

The Chandler Compadres started in 1980 as an all-male nonprofit organization dedicated to providing help to needy East Valley families. The group helped bring the Boys and Girls Club to Chandler and later combined with the Tempe branch to form the Boys and Girls Club of the East Valley. The photograph shows Mayor Boyd Dunn dedicating the new Compadre Branch and Teen Center Boys and Girls Club facility in 2009. (Courtesy of Boys and Girls Club of the East Valley.)

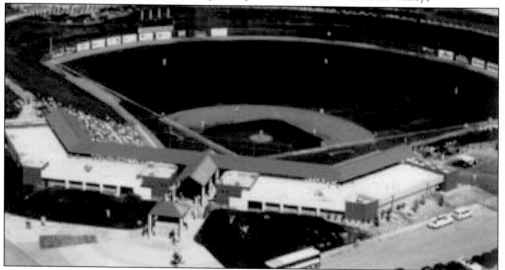

Compadre Stadium, the spring-training home of the Milwaukee Brewers, was built by the Chandler Compadres in 1985. It was the jewel of the Cactus League, and the first league stadium to offer outfield seating on a grassy berm, now standard in spring-training ballparks. While the Compadres operated the stadium, the Chandler Brewers Boosters sold tickets, food, and beverages. The Brewers were lured to an updated stadium in Phoenix in 1998. The stadium remains the headquarters of the Chandler Compadres.

ICAN provides free comprehensive programs that empower youth to be productive, self-confident, and responsible members of the community. Formed in 1991 by Henry Salinas and incorporated as a nonprofit in 1994, ICAN has served more than 7,000 area children in its 20-year history. The focus of its work centers on substance abuse and gang prevention, social and leadership development, and family and parenting programs. (Courtesy of ICAN.)

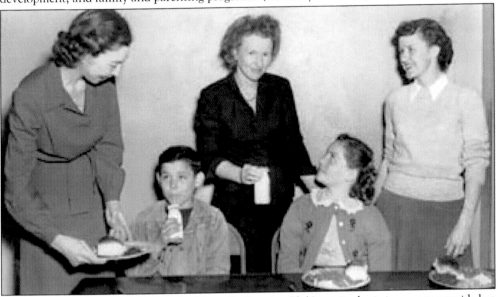

Founded in 1933 by eight women, the Chandler Service Club's original mission was to provide hot meals to Chandler's schoolchildren during the Great Depression. Club members cooked lunches for children in their own homes and later provided the funds to build a kitchen at Chandler High. In this photograph, club members (left to right) Catherine Rowe, Dorothy Austin, and Elizabeth Neat serve lunch to Flovia Romero and Barbara Ethington.

In 1954, Fr. Joseph Patterson founded Seton School, named for St. Elizabeth Ann Seton, America's first saint. Originally a junior high, it grew into a high school for the youth of St. Mary's Catholic Church. Classes were taught by the Sisters of Charity. Pictured here, the original school building was located on Chandler Boulevard east of Delaware Street. Seton moved to its current site at Dobson and Ray Roads in 1983.

Valley Christian High School was founded in 1982 in Tempe by the Bethany Community Church. The mission of Valley Christian High School is to prepare Christian students academically, physically, socially, and spiritually so they can make a difference in the world. Valley Christian has been providing educational opportunities to students in Chandler since 1996.

Nine

CHANDLER,
A LEADER IN THE VALLEY

While younger than Phoenix, Tempe, and Mesa, Chandler has long been a leader in the Valley of the Sun. From innovative agricultural techniques to standout athletes, Chandler residents can claim many accomplishments. Doctor Chandler was the community's first visionary leader. He led the way in bringing water to the valley using new irrigation technology and techniques. Chandler was also the first person to plant long-staple cotton in the valley, thereby creating an entire industry for Arizona. He led the way in alternative energy, building a hydroelectric plant and experimenting with solar energy.

The foundation that Doctor Chandler created encouraged others to pick up the mantle of leadership. Kenny England joined the local Future Farmers of America and worked his way up to become Star Farmer of America, the organization's highest honor. Chandler native Buddy Jobe bought a dusty racetrack in West Phoenix that ultimately grew into Zoomtown U.S.A. at Phoenix International Raceway, a jewel in the NASCAR empire. Chandler residents Carl and Berenice Dossey, Dale Smith, and John Clem demonstrated Chandler's elite status as home to rodeo champions and solidified the Chandler Rodeo's place on the national PRCA (Professional Rodeo Cowboys Association) circuit. Chandler has produced outstanding athletes in other sports, including Adam Archuleta, a defensive back who played in Super Bowl XXXVI (2002); Cody Ransom, the first player to hit a home run in his first two at-bats as a Yankee; and Zora Folley, the only former Chandler city councilman to fight Muhammad Ali.

Chandler's business environment has nurtured both homegrown businesses and high-tech industry. Bashas' Supermarkets began in a small store and grew into Arizona's favorite family grocery chain. Chandler's political leadership, in an effort to diversify the local economy, sought to build the Silicon Desert, bringing in Rogers Corporation, Intel Corporation, Motorola, and other semiconductor and high-tech businesses. Chandler has also led the way in societal change. Years before the Supreme Court ended segregation, Chandler High School integrated. As Chandler looks to the future, businesses like aerospace giant Orbital Sciences, biotech leader Covance Laboratories, and many others will ensure that Chandler remains a leader throughout the 21st century.

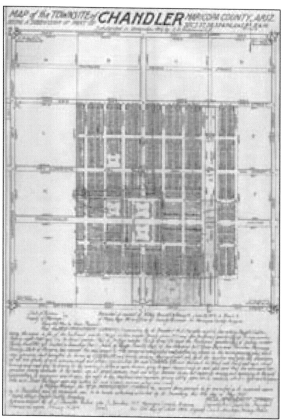

Doctor Chandler used deed restrictions to ensure that Chandler developed according to his vision for a well-planned community. Restrictions included the height of commercial buildings, distance of buildings from sidewalks, and fireproof construction. He also regulated the location of residential and industrial properties. In 1926, Chandler became the first town in Arizona to adopt a zoning ordinance, approving it before the Supreme Court upheld the legality of zoning ordinances.

Doctor Chandler was the first person to purchase a solar energy system. He bought it from Aubrey Eneas, who formed the first solar energy company. Eneas designed and built a solar motor at the Cawston Ostrich Farm in Pasadena, California. After viewing it, Doctor Chandler purchased one for his ranch for $2,160. Within a week, a windstorm destroyed the solar panels and ended Doctor Chandler's experimentation with solar energy.

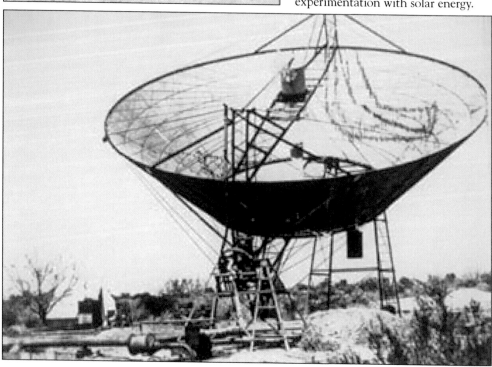

STANLEY TOMERLIN

Dramatics Club 1; Visual Aid 3,4

INEZ WATERFIELD

Pep Club 1; Y-Teens 1,2,3,4; G.A.A. 2,3,4;
Honor Society 3,4; Spanish Club 2,3,4; All
Star Volleyball Team 3.

CLELLA WIMBISH

F.H.A. 1; Pep Club 1,2,3,4; Y-Teens 1,2,3,4;
Latin Club 2,3,4; Honor Society 3,4; Dra-
matics Club 4; Spanish Club 4; G.A.A. 3,4;
Glee Club 3,4; Latin Club President 4; Y-Teens
Secretary 4; Honor Society Vice President 4;
Girls' State 3; All Star Volleyball Team 3;
Speedball Manager 4.

ROBERT TURNER

Transfer Carver High School, Phoenix, Ari-
zona 3; Jay Vee Football 3; Football 4.

For many years, African American youth could not attend high school in Chandler and had to enroll at Carver High School in downtown Phoenix, more than 20 miles away. In 1949, five years before the Supreme Court ended school segregation, Chandler High School ended its segregation policies and allowed African American students to attend. Robert Turner was one of the first African American students to attend Chandler High.

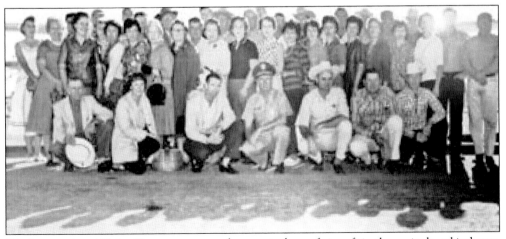

The International Flying Farmers promote the practical use of aircraft in the agricultural industry. Arizona's Flying Farmers began in 1946. Since that time, many Chandler families have been involved in the organization at the local, state, and national levels. Flying farmers use aircraft to inspect fields, herd cattle, and visit other farms. Here, unidentified flying farmers and their families pose in front of an airplane.

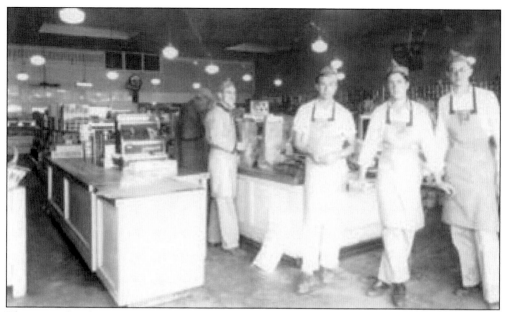

The story of Bashas' began when Najeeb and Najeeby Basha opened a store on Boston Street in 1920. They had previously owned a business in Ray, Arizona, that had burned three times. In 1932, their sons Ike and Eddie opened their first grocery store bearing the family name in Goodyear, now known as Ocotillo. Here, workers at that first Bashas' store pose at the checkout counters. (Courtesy of Bashas' Supermarkets.)

Bashas' has always been a family business. In this photograph, brothers Ike and Eddie stand at the grand opening of Bashas' No. 3, in Phoenix in 1956. The family nature of the business is best demonstrated by the spelling of the company name, indicating that the entire family assists in the operation of the business. Bashas' is the largest family-owned grocery chain in Arizona today. (Courtesy of Bashas' Supermarkets.)

David Saba Sr., an immigrant from Lebanon, opened a mercantile store in Ray, Arizona, in 1916. Three years later, he moved to Chandler and peddled wares across the state. By 1927, he had saved enough money to open a western wear store on Boston Street. Saba's Western Wear has grown into a family-owned chain with nine locations across the valley.

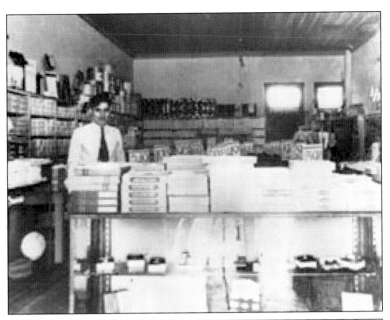

Serrano's is the oldest continually family-owned enterprise in Chandler. The original business, opened in 1919, was a clothing establishment called the Popular Store. In 1979, Ernie and Eva Serrano closed the last of their clothing stores and opened a restaurant behind the original Popular Store on Arizona Avenue. The chain of family-owned Mexican restaurants has grown to seven eateries across the East Valley.

Raul Navarrete was Chandler's first Hispanic mayor. Navarrete always called Chandler home, aside from three years of service in the Navy during World War II. He was active in the National Guard, retiring as a major after serving as a battery commander in Chandler. Navarrete was a leader in Chandler youth athletic programs and in his church parish.

When Coy Payne was elected as mayor of Chandler in 1990, he became the first African American mayor in Arizona history. Born in Texas, Payne moved with his family to Chandler Heights in 1942, and eventually settled in the NJ. Harris-Kesler neighborhood of Chandler. Payne spent 30 years working in Chandler schools as a teacher and vice principal. To combat racism, he decided to enter politics and ultimately attained Chandler's highest office.

Chandler resident Zora Folley won several military boxing titles during his Korean War service. After his discharge, Folley quickly became a top contender for the heavyweight title. On March 22, 1967, he lost to heavyweight champion Muhammad Ali. Folley was one of the first boxers to refer to Ali by his Muslim name. After the fight, Ali stated that Folley was a better boxer than Sonny Liston or Floyd Patterson.

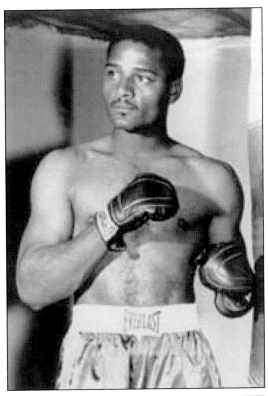

Terrell Suggs graduated from Chandler's Hamilton High School with numerous school and state football records. Suggs attended Arizona State University, where he garnered All-American honors and numerous national defensive football awards. He was drafted by the Baltimore Ravens in 2003 and experienced immediate success. He was the NFL Defensive Rookie of the Year and has been to four Pro Bowls. Suggs is the highest-paid linebacker in NFL history.

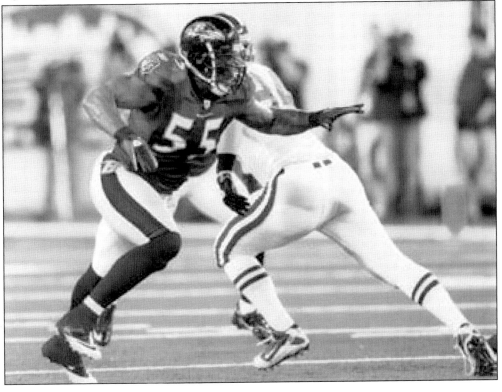

Intel is the world's largest semiconductor chip manufacturer. When Intel first came to Chandler in 1980, the company manufactured computer memory devices, but it quickly became the most profitable hardware supplier to the PC industry. Mayor Jim Patterson and several Chandler City Council members were instrumental in enticing Intel to invest in Chandler. At its state-of-the-art facilities, Intel manufactures microprocessors.

Mayor Jay Tibshraeny cuts the ribbon at the dedication of Intel's Fab 22 at its Ocotillo campus in Chandler in 2001. Over Tibshraeny's left shoulder, his successor, Mayor Boyd Dunn, looks on. Chandler's Intel campuses now represent all of Intel's business worldwide, including planning and logistics, assembly/test and development, packaging development, corporate environmental health and safety, product research, development, venture capital, and sales and marketing. (Courtesy of Intel Corporation.)

In 1966, Rogers Corporation was the first high-tech company to open in Chandler. The Chandler plant was Rogers's first operation outside of its home state of Connecticut. Today, the Chandler plants include the Advanced Materials Circuits and Durel divisions, at two sites. While Rogers has scaled back its presence in Chandler, its legacy as the city's first high-tech company has secured its place in local history.

In 1958, Chandler residents were the first in the state to form a hospital district. Hospital District No. 1 financed, constructed, and owned Chandler's first hospital, Chandler Community Hospital (pictured). Opened in 1961, the hospital was located at the corner of Chandler Boulevard and McQueen Road and served Chandler until 1984. That year, the Chandler Regional Hospital opened; it became affiliated with Catholic Healthcare West in 1999.

DISCOVER THOUSANDS OF LOCAL HISTORY BOOKS FEATURING MILLIONS OF VINTAGE IMAGES

Arcadia Publishing, the leading local history publisher in the United States, is committed to making history accessible and meaningful through publishing books that celebrate and preserve the heritage of America's people and places.

Find more books like this at
www.arcadiapublishing.com

Search for your hometown history, your old stomping grounds, and even your favorite sports team.